BASEBALL
IN ERIE

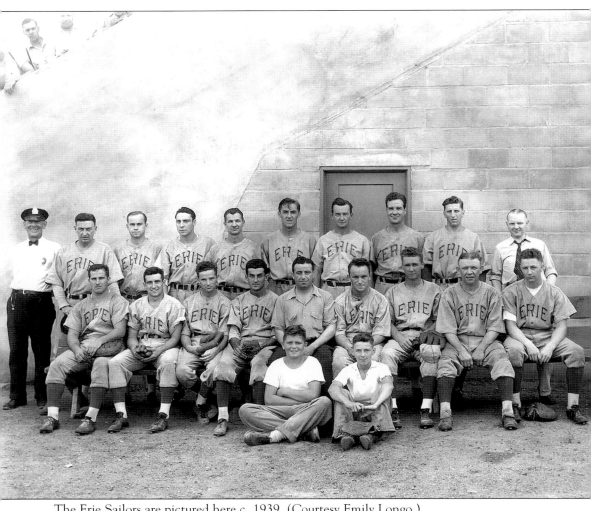

The Erie Sailors are pictured here *c.* 1939. (Courtesy Emily Longo.)

BASEBALL IN ERIE

Mark K. Vatavuk and Richard E. Marshall

ARCADIA

First published 2005

Published by Arcadia Publishing,
Charleston SC, Chicago IL, Portsmouth NH, San Francisco CA

Printed in Great Britain

Library of Congress Catalog Card Number: 2004110293

For all general information, contact Arcadia Publishing:
Telephone 843-853-2070
Fax 843-853-0044
E-mail sales@arcadiapublishing.com
For customer service and orders:
Toll-free 1-888-313-2665

Visit us on the Internet at www.arcadiapublishing.com

To our wives, Joni and Pat, for their patience, encouragement, and love.

Cover photograph credits: (front) Courtesy Gannon University Library Archives, John Johnston;
(back) Courtesy John Johnston.

CONTENTS

ACKNOWLEDGMENTS

The authors are grateful to the following individuals and organizations for their assistance in our project: Rich Abel, Marci Berlin, Diana Carlson, Paul Foust, Brad Fox, John Frey, Mike Froehlich, Ken and Larry Harden, Dan Hart, Tom Pamin, Betty Peebles, Diane Peters, Anita Smith, Ron Swanson, Al Swigonski, Chet Szymecki, Dan Tupek, the Erie Civic Center, the Erie County Historical Society, the Erie County Public Library, Gannon University, Mercyhurst College, the National Baseball Hall of Fame, the Pittsburgh Pirates, the St. Louis Cardinals, and the Topps Company.

We especially thank the following men, who shared their stories and experiences with us: Jack Arrigo, Don Chludzinski, Dallas Haight, Ed Heinrich, Fred Marsh, Joe Riazzi, George Shoskin, Ed Smrekar, and Charlie Stroup.

Two valuable resources in our research were *The Saga of Erie Sports* (John G. Carney, 1957) and *The Erie Baseball Record Book 1890–1954* (Jim Laughlin, 1954).

INTRODUCTION

Erie is in the midst of a golden age in minor-league baseball.

If this seems like a bold statement, consider that Erie has had a minor-league team in every season from 1981 to the present. Since Erie first had a professional team in the late 19th century, there has never been an era of continuous baseball to match this 24-year period. In the past, teams often ran on a shoestring and came and went with dismal regularity. But baseball never gave up on Erie, and Erie never gave up on baseball.

Maybe it is the endless winters, or the work ethic brought here by the immigrants who toiled long hours in shipyards, forges, and mills. But wherever it comes from, Erie's residents have a talent for tenacity. We do not like to give up, and we do not like people telling us we should. Critics have said our summers are too short and our ballparks not good enough, yet we have brought baseball back time and again.

In the 1890s, the fortunes of Erie's minor-league teams were front-page news in local papers. After 1894, when money was lacking to field a professional team, countless amateur clubs, many sponsored by local businesses, picked up the slack. Professional ball returned in 1905 but again lost momentum. Between 1911 and 1914, Erie teams bounced around among four leagues. By 1917, professional baseball was no more. It reappeared in the late 1920s, only to be victimized by the hard economic times of the Great Depression. Not even an appearance by Babe Ruth's New York Yankees in 1932 could keep the team alive. Despite this, Erie's baseball fans did not lose faith; they were rewarded a decade later with five championships in eight years during the 1940s.

Minor-league baseball vanished during the late 1960s and 1970s. For an entire generation, professional baseball lived on only in the stories told by parents and grandparents. In 1981, however, like a phoenix rising from the ashes, it was reborn and has since reclaimed its rightful place in the hearts of Erie sports fans. Today, at Jerry Uht Park, a city's pride shines forth brightly.

This book is a tribute to those who brought the national pastime to the shores of Lake Erie. Some players went on to the major leagues, some came tantalizingly close to "The Show," and others stayed in Erie and became a part of the community. But they all became "ours." We hope you will see some of your favorites on these pages and perhaps relive the summer nights when you cheered them on. We also hope *Baseball in Erie* will play a part in keeping this golden age alive for years to come.

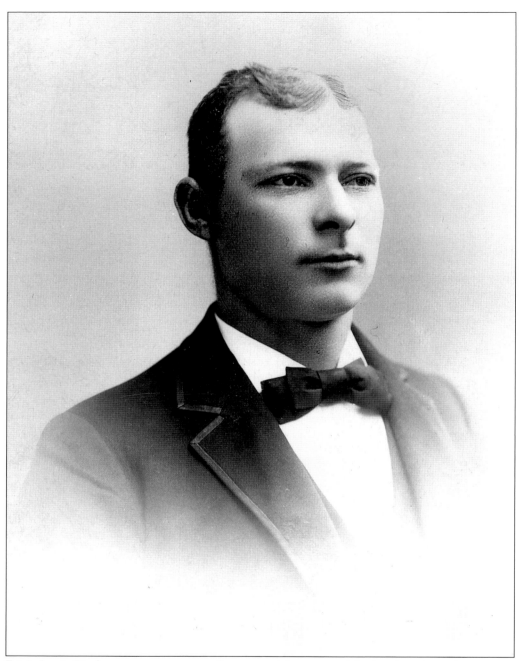

Erie's Louis Bierbauer was an outstanding second baseman with the American Association (AA) Philadelphia Athletics from 1886 to 1889. In 1890, he joined Brooklyn of the upstart Players League. The Players League lasted only one season, and the A's expected Bierbauer to return in 1891. Instead, "Louie" signed with the Pittsburgh Alleghenys of the National League (NL). The Athletics launched a storm of protest, but an arbitration board ruled in Pittsburgh's favor. Philadelphia officials referred to Alleghenys president J. Palmer O'Neill as J. "Pirate" O'Neill, and the Pittsburgh franchise earned a new nickname. (Courtesy Pittsburgh Pirates.)

One

THE EARLY YEARS
ON ERIE DIAMONDS
(1872–1899)

This 1872 amateur team included 13-year-old Tony Mullane (first row, center). Born in Cork, Ireland, Mullane moved to Erie as a youngster. He eventually became one of the premier major-league pitchers of the 19th century, compiling a lifetime mark of 284-220. Also a talented musician, skater, and boxer, Mullane was renowned as baseball's first ambidextrous moundsman. In 1884, while a member of the AA Toledo Blue Stockings, Mullane's battery mate was Moses Fleetwood Walker, widely considered to be the first black player in the big leagues. (Courtesy Gannon University Library Archives.)

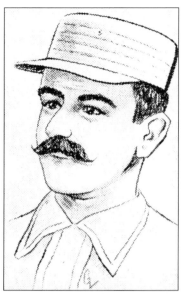

Edgar Cushman was born in 1852 in Eagleville, Ohio, and worked for several years on the railroad before turning to baseball. He reached the big leagues with Buffalo (NL) in 1883. The left-handed pitcher posted a 62-81 career record. Thereafter, Cushman was the proprietor of Erie's Corner Restaurant at 801 State Street. He died in 1915. (Courtesy Gannon University Library Archives.)

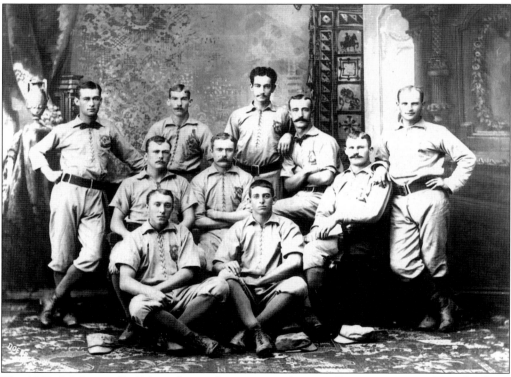

The 1882 AA Louisville Eclipse featured two men with strong Erie connections. Tony Mullane (third row, third from left) frequently "jumped" teams in search of a better contract. He was suspended for the entire 1885 season and missed parts of two others because of salary disputes. As a result, he lost the chance to win 300 games and a likely place in the Baseball Hall of Fame. Erie native Charley Strick (third row, fourth from left) was a barehanded catcher, in an era when pitchers threw from a distance of 50 feet. (Courtesy Gannon University Library Archives.)

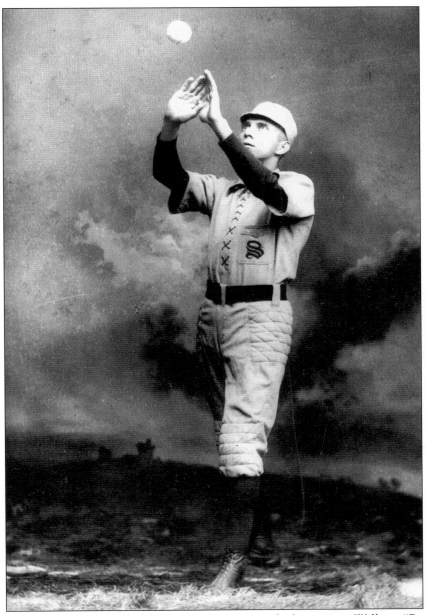

One of many 19th-century Erie County residents to reach the majors, William "Bones" Ely (seen here as a member of the 1890 AA Syracuse Stars) was a 14-year veteran of the big leagues. Born in North Girard (Lake City), Ely began his career in 1884 as a pitcher for Buffalo (NL). Shortly thereafter, he switched to shortstop and played for a number of AA and NL teams, predominantly St. Louis (NL) and Pittsburgh (NL). Bones tallied 1,331 hits to go with a lifetime .258 batting average. He also led the NL in fielding in 1898 and was captain of the Pirates in 1897. In 1901, he was released by Pittsburgh for allegedly trying to lure players to the new American League. His replacement with the Pirates was future Hall of Famer Honus Wagner. William Ely died in Berkeley, California, in 1952 at age 88. (Courtesy Gannon University Library Archives.)

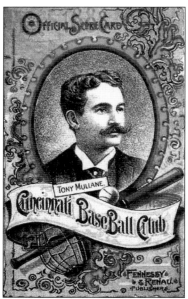

Handsome Tony Mullane was a crowd favorite, especially among members of the fairer sex. His regal manner (no drinking, smoking, or gambling) and dashing good looks earned him nicknames, notably "The Count" and "The Apollo of the Box." No slouch at the plate, the switch-hitting Mullane hit .243 in 2,720 major-league at-bats. He completed his career with Cleveland in 1894, then settled in Chicago, where he worked with the local police department.

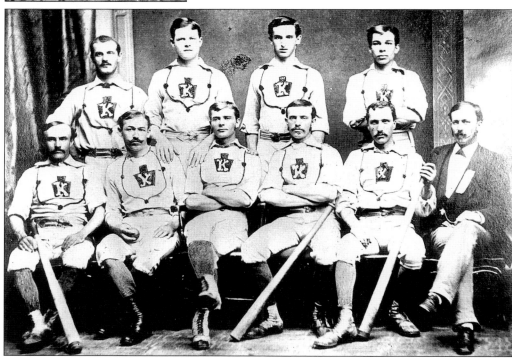

The 1874 Keystones, Erie's first prominent town team, competed against other amateur clubs, including Meadville, Buffalo, New Castle, and Girard's "nameless" team. On October 2, the Keystones hosted the Philadelphias of the National Association (baseball's first professional league). Future Hall of Famer Candy Cummings, the inventor of the curveball, was in the pitcher's box as the Philadelphias prevailed, 25-4. From left to right are the following (identified by last name only): (first row) McCarty, Hawk, Charleston, Whitcomb, Hall, and Moore; (second row) Charleston, Fogarty, Jarecki, and Swalley. (Courtesy Gannon University Library Archives.)

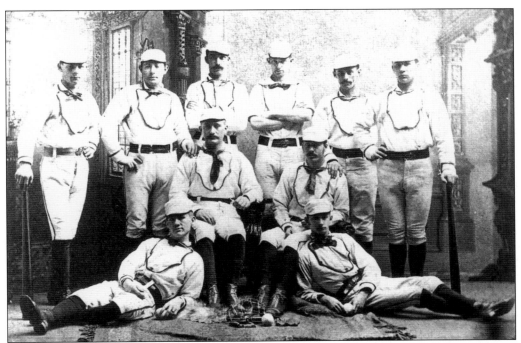

The 1884 Erie Jarecki Manufacturing nine was a local shop team that boasted two future major-leaguers. Conrad "Dell" Darling (second row, far right) was a reserve catcher during his six-year career. Louis Bierbauer (second row, far left) was a slick-fielding second baseman who hit .267 over 13 seasons. In 1885, Bierbauer and Darling teamed with Erie pitcher Mike Morrison on the Erie Olympics. (Courtesy Gannon University Library Archives.)

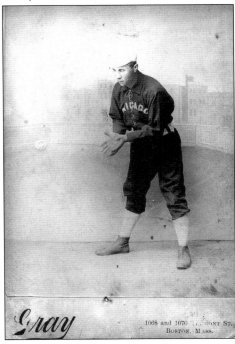

Dell Darling was a member of the Chicago White Stockings (NL) from 1887 to 1889. Among his teammates were Billy Sunday, future Hall of Famer "Cap" Anson, and John Kinley Tener. After Tener's brief pitching career, he was elected governor of Pennsylvania and later became president of the National League. Dell Darling passed away in 1904 at age 42. Two years later, two of his sons drowned in an accident at Presque Isle's Misery Bay. (Courtesy Gannon University Library Archives.)

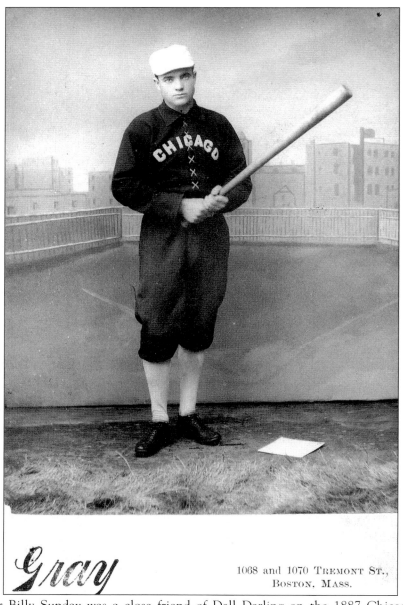

Gray

1068 and 1070 TREMONT ST.,
BOSTON, MASS.

Outfielder Billy Sunday was a close friend of Dell Darling on the 1887 Chicago White Stockings. One of the fastest base runners of his time, Sunday stole 84 bases in 1890. He then retired from the game at age 27 and eventually became a popular evangelist. In 1911, his revival swept into Erie for a six-week stint, beginning May 28. Local churchgoers constructed a special tabernacle for his services at 12th Street and Myrtle, from which he tried to save the "whiskey-soaked" city. Early in his revival, Sunday declared, "If ever a town in this country needed a cyclone of religion and a tidal wave of salvation, it is Erie." Sunday took time out to participate in the first interscholastic track meet ever held in the city. He ran the 50-yard dash and threw the hammer, all to the delight of the athletes and spectators. By the end of his stay, Sunday had converted 5,312 souls and collected $11,565.67. (Courtesy Gannon University Library Archives.)

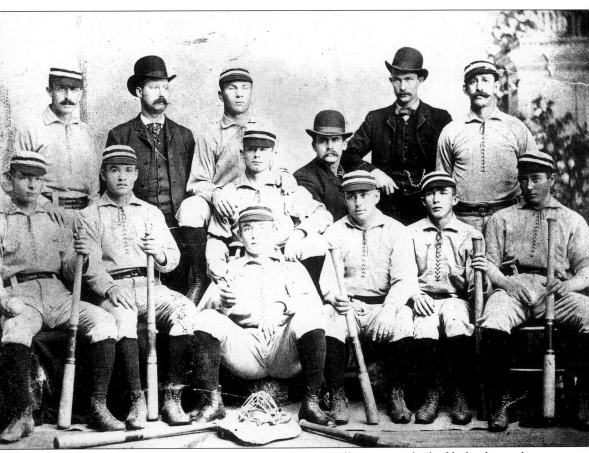

The 1885 Erie Olympics team was organized by Archie Miller, a man who had helped introduce Atlanta to the national pastime a few years earlier. With the Olympics in tow, Miller then worked with other promoters to establish a league. Teams in this quasi-professional circuit represented Erie, Youngstown, Dayton, Springfield (Ohio), Lexington, and Frankfort. However, financial problems were widespread, and the short-lived league disbanded in June of 1885. Nonetheless, three local men were Olympics stalwarts who later made their mark in the major leagues: Louis Bierbauer (seated, far left), Mike Morrison (seated, far right), and Dell Darling (standing, third from left). Morrison posted a record of 12-25 with the Cleveland Blues (AA) in 1887. (Courtesy Gannon University Library Archives.)

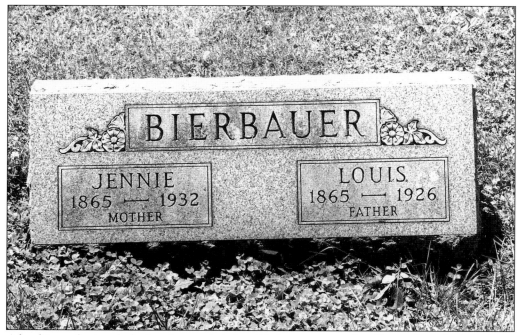

After his professional playing days ended, Lou Bierbauer returned to Erie and worked as a brass molder. He died in 1926 at age 60. Nearly 30 years later, local historian John Carney sought out Bierbauer's grave site at Erie Cemetery. Finding it unmarked, Carney established a fund seeking donations for a proper stone. This memorial was finally placed in 1954.

BASEBALL MAJOR LEAGUES IN 19TH CENTURY

National Association (NA) — 1871–1885

National League (NL) — 1876–present

American Association (AA) — 1882–1891

Union Association (UA) — 1884

Players League (PL) — 1890

SIGNIFICANT RULE CHANGES IN 19TH CENTURY

1881 — Distance from pitcher to home plate increased from 45 feet to 50 feet.

1883 — Pitchers permitted to throw overhand in American Association.

1884 — Pitchers permitted to throw overhand in National League.

1893 — Distance from pitcher to home plate increased to 60 feet 6 inches.

Two

BASEBALL ALL AROUND
THE TOWN
(1900–1932)

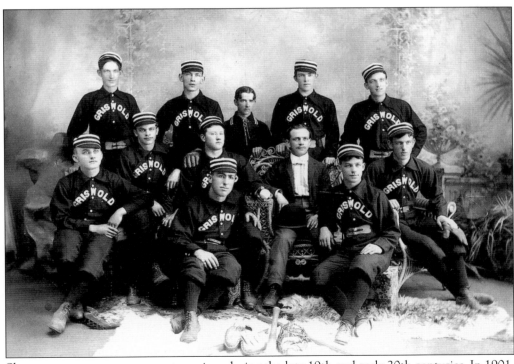

Shop teams were common amateur nines during the late 19th and early 20th centuries. In 1901, the Erie City (Industrial) League was formed, with four squads competing: Duquesnes, Erie City Iron Works, Griswolds, and Pennsylvania Railroads. Games were played at the newly constructed Four Mile Creek Park. The Griswolds (posing here in a formal studio setting) were champions in 1901 and 1903. (Courtesy Gannon University Library Archives.)

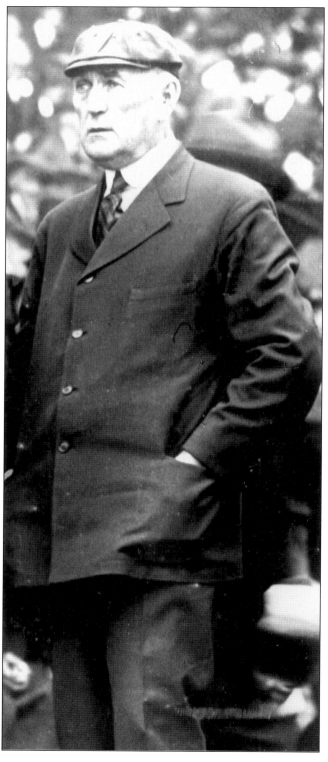

Hank O'Day is the only man to have played, managed, and umpired in the major leagues. As a pitcher, O'Day posted a lifetime mark of 73-110 from 1884 to 1890. He closed out his playing career in 1893 with the Eastern League champion Erie Blackbirds. O'Day was a "man in blue" from 1894 to 1927, with breaks in 1912 and 1914 when he managed the Reds and Cubs. A highly respected arbiter, O'Day was selected to umpire in the first modern World Series (1903). In 1908, he earned a place in baseball lore: During the late-season "Merkle Boner" game between Chicago and New York, O'Day ruled Giant Fred Merkle out for failing to touch second base as the game-winning run scored. This ultimately cost New York the pennant, and the Cubs went on to capture what would be the ballclub's last World Series title of the 20th century. (Courtesy National Baseball Hall of Fame.)

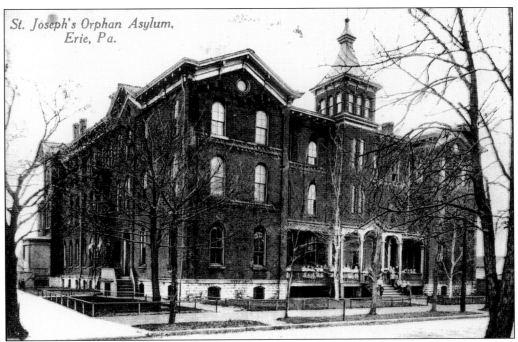

St. Joseph's Orphan Asylum, Erie, Pa.

Michael Joseph Donlin was born on May 30, 1878, in Peoria, Illinois. At age eight, his parents were killed in the collapse of a railroad bridge. He was then sent to St. Joseph's Orphanage in Erie, located on East Third Street, between French and Holland. (Courtesy Sisters of St. Joseph.)

Mike Donlin left Erie in 1897. By 1899 he was an outfielder for the St. Louis Cardinals. Donlin was a .333 lifetime hitter over his 12-year major-league career. No stranger to alcohol, nightlife, and fisticuffs, Donlin spent most of 1902 in jail for assaulting actress Minnie Fields. This was but one of many incidents that plagued the hotheaded Irishman. Yet he was a fan favorite, especially in New York, where "Turkey Mike" was a member of John McGraw's Giants (1904–1908). In 1909, Donlin left baseball and formed a vaudeville act with his wife, actress Mabel Hite.

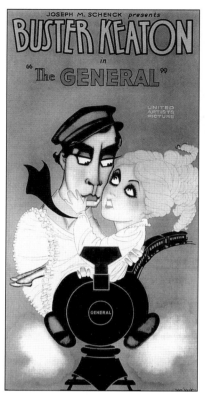

While on vaudeville stages in 1909 and 1910, Mike Donlin discovered motion pictures. After retiring from baseball for good in 1914, he moved to Hollywood. From then until his death in 1933, Donlin appeared in some 50 movies (both silent and talkie), largely in supporting or bit roles. He even portrayed himself in *Right off the Bat* (1915), the first feature-length film about baseball. Donlin appeared as a Union general in Buster Keaton's 1927 classic *The General*, considered to be one of the greatest comedies of the silent era. (Courtesy United Artists/MGM.)

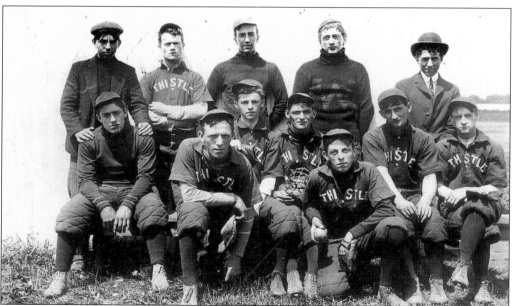

By the late 1880s, amateur baseball was the rage in Erie. Town teams represented the local citizenry in contests against clubs from nearby cities. Erie's Tribunes and Independents took on squads from Meadville, Titusville, and Franklin. Meanwhile, shop teams played in intracity leagues. Pictured here are members of the 1903 Erie Thistles. (Courtesy Gannon University Library Archives.)

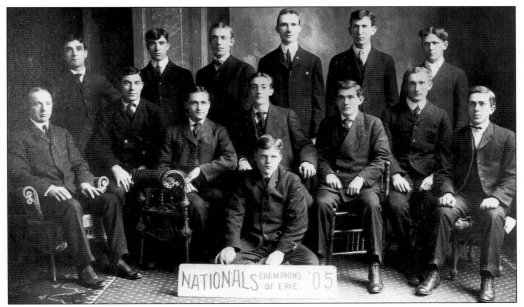

In 1905, Erie was ready to stage its own fall classic for the city's amateur championship. In the October 29th game, the Nationals bested the Erie Brewing Company, 6-5. Afterward, the victors were photographed in their Sunday best. From left to right are the following: (first row) Charley Sechrist, Hoppy Flanagan, Happy Haft, manager Sher Hickey Sr., Pooch Hart, Danny Bickford, and Billy Ruland; (second row) Marty Donlin, Charlie Kaltenbacher, Joe Heidt, Sam Seifert, John Hickey, and Dan Leyden. Sitting in front is mascot Billy Baumgartner. (Courtesy Gannon University Library Archives.)

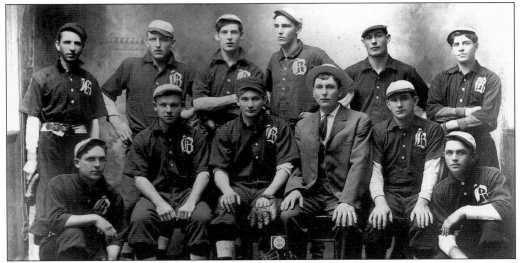

The Erie Brewing Company, makers of legendary Koehler Beer, was an Erie institution until 1979. The company sponsored teams for many years, including this 1901 edition. From left to right are the following: (first row) Billy Steinwachs, Johnny Froess, Laurey Wolfe, manager Charley Honard, Jim Toohey, and Henry Steinwachs; (second row) George Schley, Oscar Roesch, George Honard, Jake Brabender, Charley Sertz, and George Johannes. (Courtesy Gannon University Library Archives.)

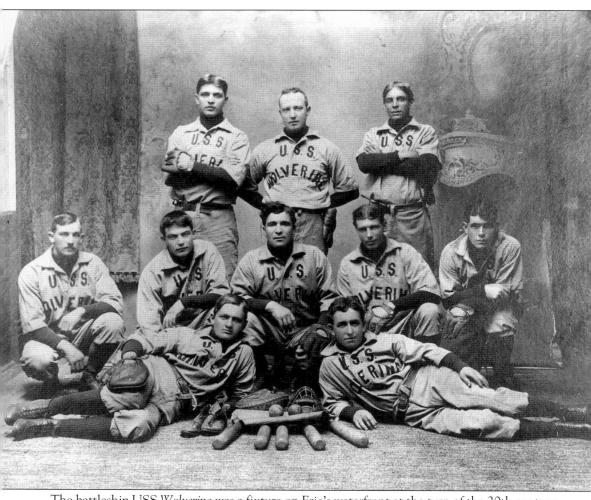

The battleship USS *Wolverine* was a fixture on Erie's waterfront at the turn of the 20th century. Several crew members (some of whom took part in the Spanish American War) organized a baseball team. When the ship cruised the Great Lakes, the Wolverines played local nines at various ports of call. This 1900 team included Carl Kestel (second row, far left), Capt. Emmett Bean (third row, center), and Johnny Dorsey (third row, far right). (Courtesy Gannon University Library Archives.)

This unidentified team was a local 1908 amateur champion. Presumably, the derby-clad gentleman at the far left was the team's manager. Most team photographs of this era included a mascot, usually a dog or small child. (Courtesy Gannon University Library Archives.)

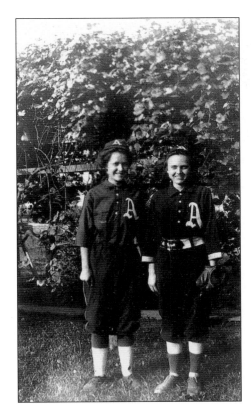

In terms of mascots, this 1908 team was unique. At home games, these two young lasses graced the ballfield—no doubt to the delight of the crowd and players. (Courtesy Gannon University Library Archives.)

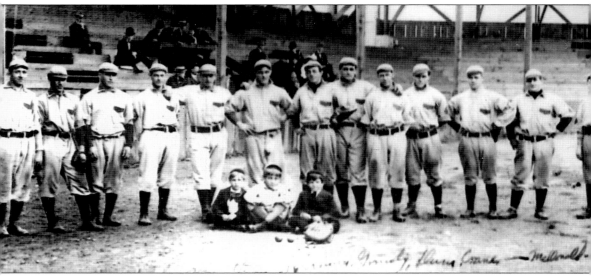

The 1906 Erie Fishermen were champions of the Class D Interstate League, beating out Kane, Bradford, Punxsutawney, Patton, DuBois, Oil City, and Olean. Pictured here, from left to right, are Tom Philbin, Nick Cole, Bill Cranston, Johnny Welsh, manager Tom O'Hara, Chuck Strom, Toby Sherman, Steve Grandy, Bill Dunn, Tony Crane, ? Clark, John McDonald, and Alexander Reilly. Team owners were Frank Baumeister and Dan Koster. (Courtesy Gannon University Library Archives.)

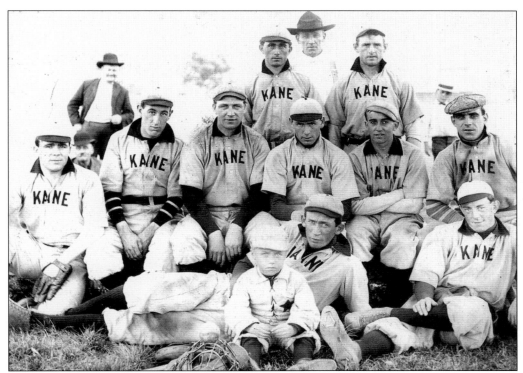

The Kane Mountaineers joined the Interstate League in 1905 and remained a rival of the Fishermen into 1907. The 1907 campaign was an erratic one. The season began with eight teams, but midway through the year two clubs dropped out. A "second" season started, only to stop a month later when two more teams folded. Finally, a four-team third season was played; Erie was runner-up. The loss of half its teams for financial reasons did not bode well for the Interstate League's future. In early 1908, the entire league dissolved. (Courtesy Gannon University Library Archives.)

This advertisement for baseball suits appeared in the *Erie Dispatch* in 1913. The Reach Company produced uniforms and other items needed for a well-appointed team. The Palace Hardware House was located at Ninth and State Streets. Nearly a century later, the building remains a downtown Erie landmark.

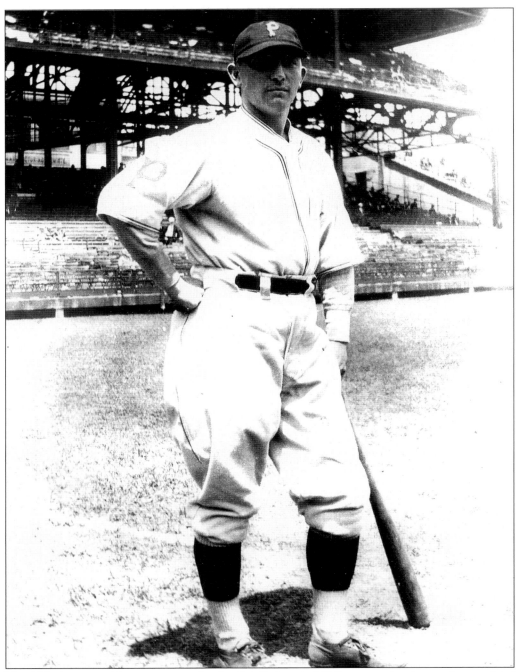

Vic Aldridge was a 19-game winner for the Erie Sailors in 1915, accounting for nearly one-third of his team's victories. He posted a lifetime mark of 97-80 over nine big-league seasons, including two solid years with the pennant-winning Pittsburgh Pirates (1925 and 1927). One of Aldridge's Erie teammates was future Hall of Famer Stan Coveleski. In the 1925 World Series, Aldridge tossed two complete-game wins over the spitballing Coveleski as the Pirates edged the Washington Senators four games to three. (Courtesy Pittsburgh Pirates.)

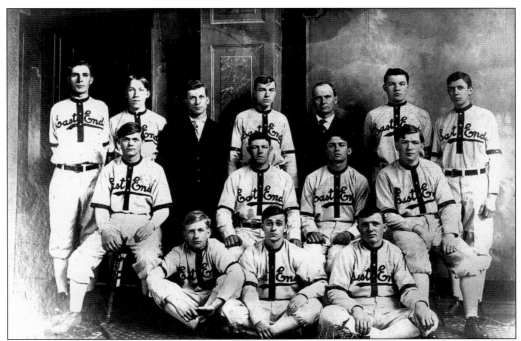

Here is a portrait of Erie's 1909 East Ends amateur team. From left to right are the following (identified by last name only): (first row) Caryl, Stark, and Jagemann; (second row) Fogarty, Scharrer, Donlin, and MacIntyre; (third row) Johnson, Crawford, Branif, Sweeney, manager Guelcher, Casey, and Strucher. (Courtesy Gannon University Library Archives.)

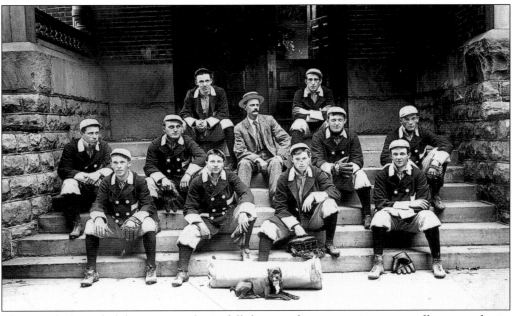

This nattily attired club appears to be in full dress, perhaps preparing to set off on a road trip. The c. 1916 team is unidentified. (Courtesy Gannon University Library Archives.)

BASE BALL

At Perry Field, Today

CANTON vs. ERIE

Game Called 3 P. M.

LADIES ADMITTED FREE EVERY MONDAY AND FRIDAY.

General Admission25 cents
Grandstand50 cents
Box Seats75 cents

By 1913, Erie had jumped to Class B minor-league ball, with a franchise in the Interstate League. This eight-team circuit included Akron, Canton, Columbus, Steubenville, Wheeling, Youngstown, and the Zanesville Flood Sufferers. The league folded on July 21, 1913, with the Sailors atop the standings with a stellar record of 52-21. Advertisements for upcoming games (such as this one against the Canton Senators) were commonplace in local newspapers. Perry Field, located at West 10th and Weschler Streets, was Erie's home field from 1908 to 1916.

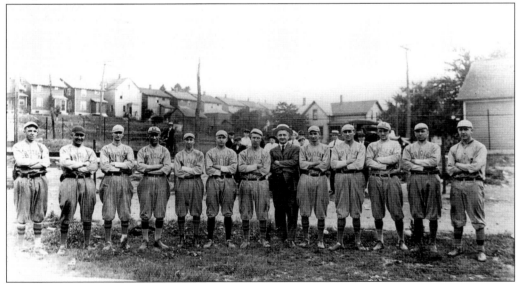

The 1919 Orioles squad was one of Erie's finest amateur teams of the era. From left to right are Bill Halloway, "Shunnell" Emling, "Lefty" Owen, Jess Hammerman, George Wingerter, Harold Ford, Eugene McMannus, unidentified, Al Neubeck, "Honey" Vogt, Johnny Mattis, Nick Carter, and Tony Kuntz. (Courtesy Gannon University Library Archive.)

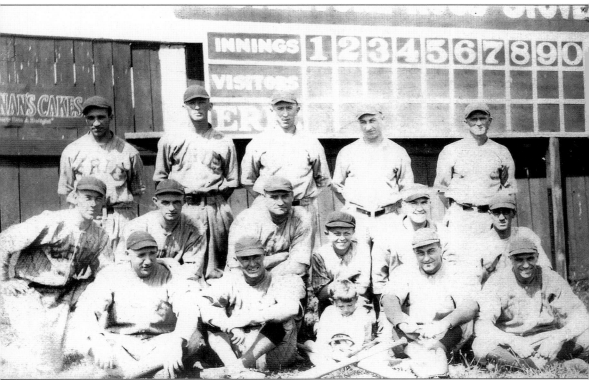

Erie was without minor-league baseball from 1917 through 1924. In 1925 and 1926, a franchise was secured in the "unofficial" Ohio and Pennsylvania League, with Ed Hiller as owner. The Sailors squared off against Canton, Massillon, New Castle, Youngstown, and the Cleveland Tellers. Few, if any, records were kept. Home games were played at the Pennsylvania Railroad Grounds (East 18th and Ash Streets). The 1925 contingent is pictured here. Members included catcher Julius "Jocko" Munch (second row, third from left) and two mascots: "Muckle" Hiller (second row, fourth from left) and Mike Munch (just behind the bats). The 1926 team featured Jocko Munch and former major-leaguer Hugh Bedient. In 1928, the Sailors joined the Class B Central League. During that season, Ed Hiller turned over the reins of the club to George Miller. Thereafter, Hiller remained active in local sports. He died while umpiring a game at Bayview Field in 1933. Ed Hiller was only 45 years old. (Courtesy Gannon University Library Archive.)

Buffalo native Frankie Pytlak was the catcher for the 1930 Sailors, hitting a solid .330. He joined the Cleveland Indians in 1932 and remained with the Tribe through 1940, batting .315 as a starter in 1937. His big-league career, abbreviated by numerous injuries and military service during World War II, featured a lifetime batting average of .282. On August 20, 1938, Pytlak broke the record for catching a baseball dropped from the greatest height, when he snared a ball that was released from the 706-foot-high Cleveland Terminal Tower. (Courtesy Gannon University Library Archives.)

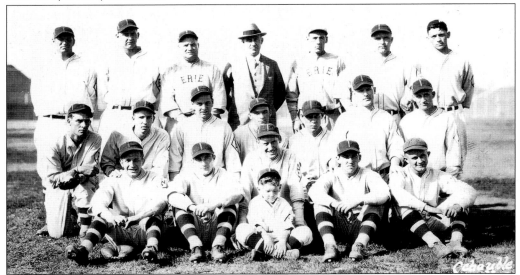

The heavy-hitting 1930 Erie Sailors finished in second place in the Central League, with every regular batting over .300. Jocko Munch (third row, third from left) was a fixture in Erie baseball from the late 1920s to the early 1950s, both on the field and as an executive. To the right of Munch is Mayor Joseph Williams. Frankie Pytlak is in the first row, far left. Outfielder Bailey Groseclose (second row, sixth from left) hit .348. Pitcher Bob Kline (third row, second from left) posted an impressive 23-9 record. (Courtesy Gannon University Library Archives.)

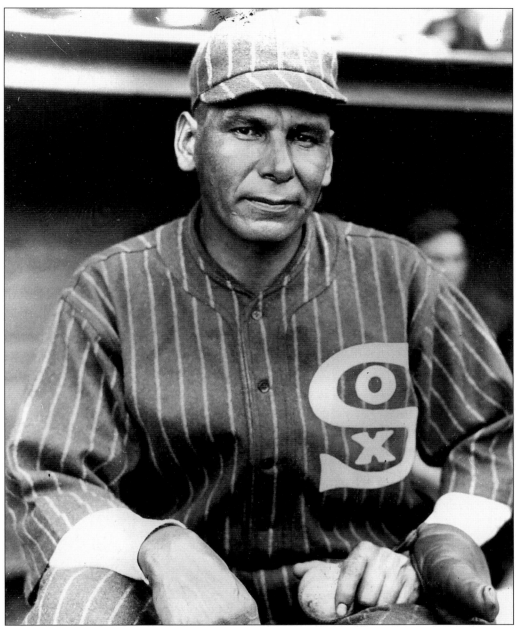

In 1932, the Sailors returned to the Central League as an affiliate of the New York Yankees. Former major-league hurler Charles Albert "Chief" Bender handled much of the managing chores. A Native American of the Chippewa tribe, Bender had been one of the aces of Connie Mack's Philadelphia Athletics from 1903 to 1914. He played in five World Series for the A's, and Mack called the "Chief" his greatest "money pitcher" ever. Bender posted a career mark of 210-127 and an ERA of 2.46. He is credited with inventing the nickel curve, known today as the slider. Erie was but one stop in his long coaching and managing career, including a stint with the Chicago White Sox in 1925 (when this photograph was taken). Bender was elected to the Hall of Fame in 1953. (Courtesy National Baseball Hall of Fame.)

ERIE MINOR-LEAGUE TEAM RECORDS 1890–1916

YEAR	NAME	LEAGUE	RECORD	MANAGER
1890	[None]	Iron and Oil	52-30	P. McCully
1891	# [None]	Iron and Oil	51-28	unknown
1893	* Blackbirds	Eastern	63-41	unknown
1894	Blackbirds	Eastern	57-50	Morton
1905	Fishermen	Interstate	58-39	McLaughlin and Burke
1906	* Fishermen	Interstate	65-41	T. O'Hara
1907	Fishermen	Interstate	65-51	T. O'Hara
1908	Fishermen	Interstate	4-14	unknown
1908	Sailors	Ohio & Penna.	42-79	T. Crane
1909	Sailors	Ohio & Penna.	48-69	M. Broderick
1910	Sailors	Ohio & Penna.	55-69	M. Broderick
1911	Sailors	Ohio & Penna.	77-54	B. Gilbert
1912	Sailors	Central	75-55	B. Gilbert
1913	# Sailors	Inter-State	52-21	B. Gilbert
1914	Yankees	Canadian	64-57	H. Smith
1915	Sailors	Central	64-58	L. Quinlan
1916	Sailors	Inter-State	26-37	J. Savage

* — League champions
— In first place when league disbanded

Three

BARNSTORMIN'
THROUGH THE YEARS

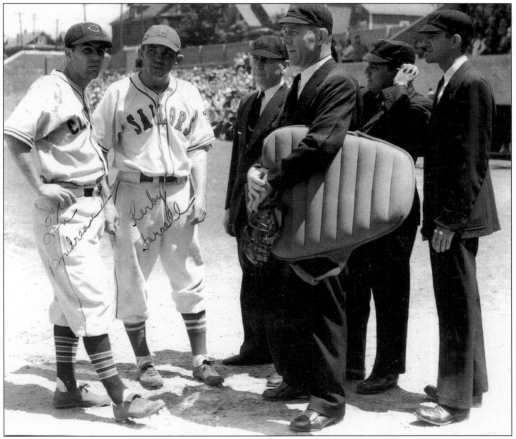

On July 8, 1942, Cleveland's "Boy Wonder," Lou Boudreau, brought his Indians to Erie for an exhibition game with the Sailors. The Tribe had an easy time with the "Gobs," winning 10-1 with the help of a Boudreau homer. This was the 24-year-old's first year as player-manager. Here, Boudreau (far left) meets with Erie's own player-manager, Kerby Farrell, and the umpires. An outstanding defensive shortstop, Boudreau fashioned a Hall of Fame career and managed the Indians to a World Championship over the Boston Braves in 1948. Farrell played for the Braves in 1943 and the White Sox in 1945, and managed the Indians in 1957. (Courtesy Betty Peebles.)

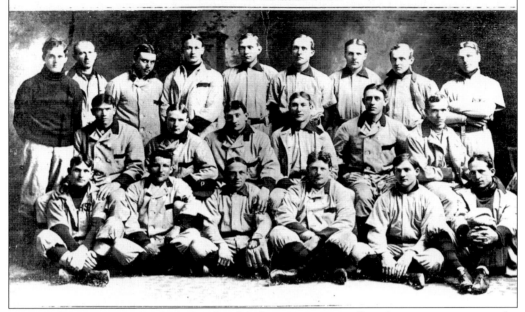

On Sunday, August 26, 1906, Pittsburgh's Pirates came to Erie for a game against the Fishermen. The above photograph shows the 1904 Pirates, several of whom played in the 1906 exhibition, notably Clarence "Ginger" Beaumont (first row, fourth from left), Fred Clarke (first row, far right), and Honus Wagner (second row, third from left). The 1906 Pirates finished in third place in the National League. Anticipation was high for the August 26 game, as a crowd of 3,000 awaited Erie ace curveballer Johnny Welsh's first pitch. (Courtesy Pittsburgh Pirates.)

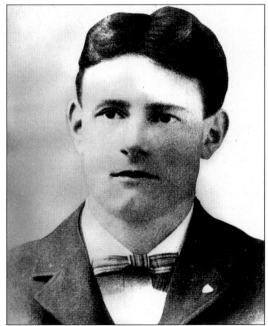

Speedy Pittsburgh center fielder Ginger Beaumont was the first batter to step to the plate in the 1903 World Series, but Boston ultimately upset Fred Clarke's Pirates in the initial fall classic. Beaumont won the NL batting title in 1902 with a .357 average. He retired after the 1910 season as a .267 lifetime hitter. (Courtesy Pittsburgh Pirates.)

34

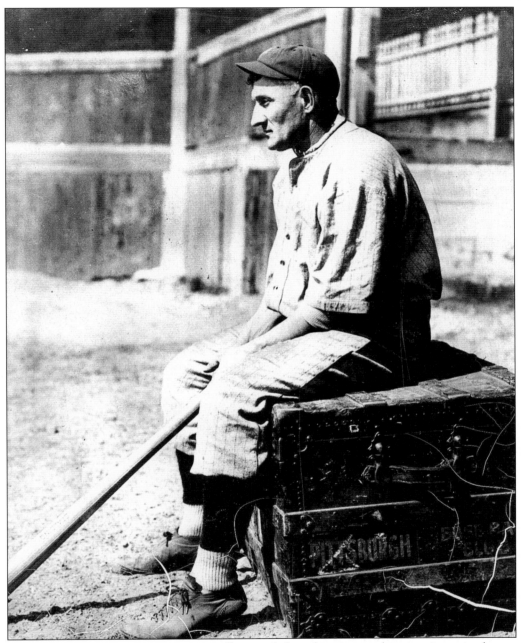

John Peter "Honus" Wagner is universally regarded as the greatest shortstop in major-league history. When the Hall of Fame held its first election in 1936, Wagner joined Cobb, Ruth, Mathewson, and Walter Johnson as the inaugural group of inductees. Initially an outfielder, Wagner took over as Pittsburgh's starting shortstop in 1901, when Lake City's Bones Ely was banished from the team. In 1906, Wagner was on his way to winning the fourth of his eight NL batting titles, ending the year at .339. A lifetime .328 hitter, he stole 723 bases and 4 times led the league in fielding. However, the "Flying Dutchman" was held hitless by the Fishermen on that late-August Sunday in 1906. (Courtesy Pittsburgh Pirates.)

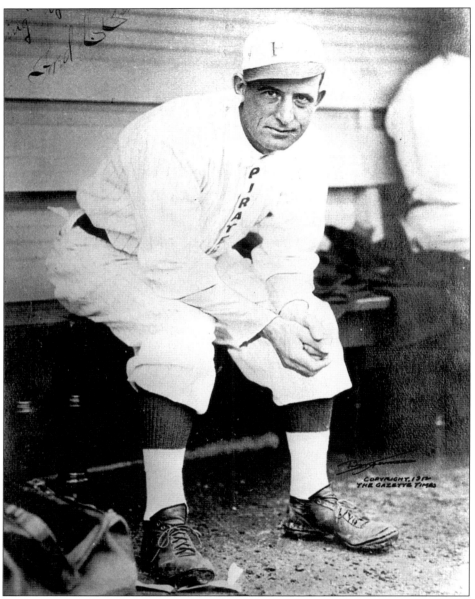

Player-manager Fred Clarke was one of Pittsburgh's greatest players. In 1906, he patrolled the outfield, batted .309, and managed the Pirates to a record of 93-60. His 1909 team would defeat Ty Cobb's Tigers in the World Series. But he was not as lucky against Erie's Johnny Welsh held the Pirates to nine hits, frustrating batters with his slow curve. With Wagner at bat in the ninth inning, Erie was ahead by one run. A dispute over a pickoff attempt at second base escalated until Clarke threatened to pull his team off the field. He relented only after Erie owner Dan Koster said he would withhold Pittsburgh's share of the gate receipts. Wagner then walked, but the Pirates failed to score. A disappointed Clarke stated, "We came here to play ball on the square and beat Erie as badly as we could. I am ashamed to go home with that defeat to our credit." The *Erie Dispatch* crowed, "Pirates Were Badly Whipped." (Courtesy Pittsburgh Pirates.)

Cleveland Naps
Coming to Erie

The first exhibition game of the regular season has been announced for the afternoon of Monday, July 7, at Perry field, when the Cleveland Americans come for a centennial celebration.

July 1913 marked the centennial of Oliver Hazard Perry's victory over the British in the Battle of Lake Erie. To help celebrate, the Cleveland Naps played an exhibition game against the Erie Sailors on July 7, appropriately at Perry Field. As a special memento, Clayton Burns of Erie fashioned a baseball bat made of wood from the *Niagara*, Perry's flagship; the bat was presented to Sailors manager Larry Quinlan. The Sailors eked out a 3-2 win, and kept the great Napoleon Lajoie off the base paths.

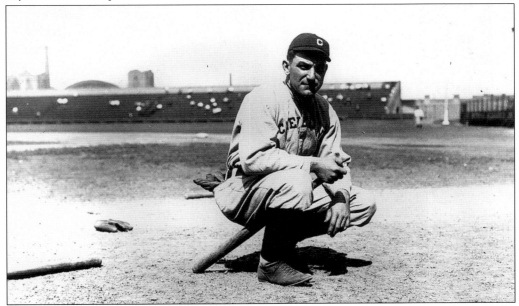

Napoleon Lajoie was such a popular player in Cleveland that, from 1903 through 1914, the team was called the Naps in his honor. With a .338 career average, he was one of the best batsmen of his time. In 1913, second baseman Lajoie enjoyed his last great season in a Cleveland uniform, batting .335. He was sold to the Athletics in 1915, and the Naps were renamed the Indians. (Courtesy National Baseball Hall of Fame.)

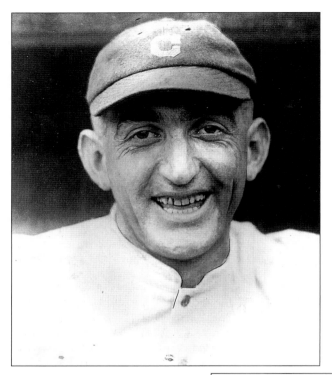

Perry Field may not have been a "field of dreams" for "Shoeless" Joe Jackson, but he did single, steal two bases, and score a run in Cleveland's 3-2 loss to the Sailors. Jackson would go on to greater fame (and infamy) as a member of the Chicago White Sox. Six years after his visit to Erie, the lifetime .356 hitter was implicated in baseball's worst scandal: the fix of the 1919 World Series. (Courtesy National Baseball Hall of Fame.)

Popular shortstop Ray Chapman played his first full season as a regular for the Naps in 1913. On August 16, 1920, Chapman was beaned by Yankee submariner Carl Mays. Chapman died 12 hours later. He remains the only player to die from injuries suffered in a major-league game. Cleveland ultimately won the 1920 World Series, and Chapman's widow received a full winner's share of nearly $4,000. (Courtesy National Baseball Hall of Fame.)

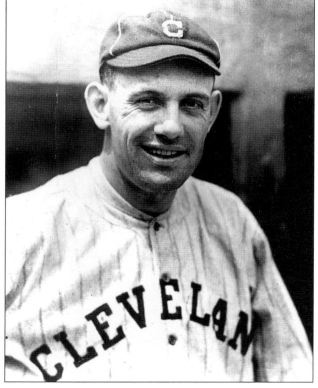

OFFICIAL BOX SCORE

HOMESTEAD—	AB.	R.	H.	O.	A.	E.	ERIE—	AB.	R.	H.	O.	A.	E.
B. Williams, ss.	4	1	1	1	2	0	Moske, 1b.	4	1	1	5	0	1
V. Harris, lf.	3	1	0	0	0	0	Fleming, lf.	3	1	0	1	0	0
Graham, lf.	3	0	0	0	0	0	Layden, cf.	3	0	1	3	0	2
Washington, 1b.	4	2	3	6	0	0	Rugg, 3b.	3	1	1	3	0	0
Smith, 3b.	4	2	2	0	1	0	Paskert, rf.	3	0	1	0	0	0
M. Harris, 2b.	4	0	0	3	1	0	Bible, 2b.	3	0	1	3	4	0
Gray, cf.	3	1	0	1	0	1	Yengst, ss.	2	0	0	0	2	2
Pierce, c.	3	1	1	9	0	0	O'Connell, c.	3	0	0	4	1	1
J. Williams, p.	3	0	2	1	1	0	Berry, p.	1	0	0	0	0	1
							a-Raley, ss.	1	0	0	2	0	1
Totals	31	8	9	21	5	1	Totals	26	3	5	21	7	8

a—Batted for Yengst in sixth.

HOMESTEAD	4	0	0	0	0	3	1	—8
ERIE	0	0	0	0	0	3	0	—3

Two-base hits, J. Williams, Pierce, Paskert, Bible; three-base hit, Smith; left on bases, Erie 6, Homestead Grays 4; first base on balls, off Williams 4, Berry 1; struck out, by Williams 9, Berry 2; passed ball, O'Connell; sacrifice hit, Graham; stolen bases, Gray, J. Williams, Pierce; hit by pitcher, by Berry (Gray); umpires, O'Toole and Di Nunzio.

On June 29, 1926, Erie's Sailors (members of the unofficial Ohio and Pennsylvania League) hosted the Homestead Grays at Athletic Field. The Grays featured ace right-hander Smokey Joe Williams. Erie was soundly defeated, as Williams struck out nine and the Sailors committed eight errors. In 1926, Homestead completed its barnstorming season with a remarkable record of 102-6-6.

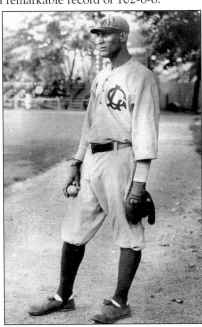

"Smokey Joe" Williams, a six-foot-five-inch Texan, was of African American and Native American ancestry. A soft-spoken fire-baller, he is recognized as the greatest black pitcher of his day. While with the Homestead Grays in 1930, the 44-year-old Williams struck out 27 in a 12-inning, one-hit victory over the Kansas City Monarchs. In exhibition games against major-leaguers, Smokey Joe's record was 22-7-1, including 12 shutouts. He was elected to the Hall of Fame in 1999. (Courtesy National Baseball Hall of Fame.)

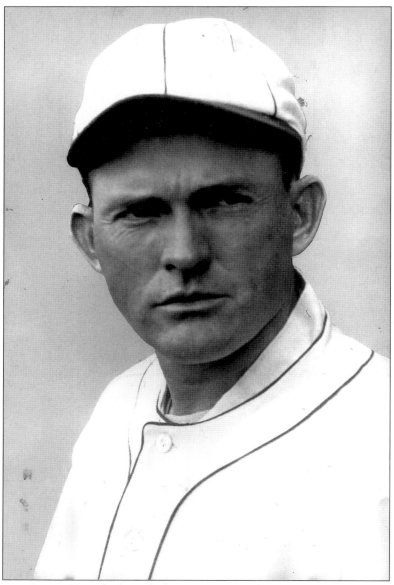

When the great Rogers Hornsby brought his St. Louis Cardinals to Erie for an exhibition game against the Sailors on August 12, 1926, his team was on the way to its first world championship. The Cardinals defeated the mighty Yankees in a dramatic seven-game series. Player-manager Hornsby kept an unexpectedly low profile during his visit to Erie. The *Erie Dispatch-Herald* reported that "the Rajah" appeared in town that morning, but "his physical condition was such that it did not warrant him to play in an exhibition game." A few days later, word filtered back to Erie that the Cardinals had been booked for two exhibitions on the same day, accounting for the absence of Hornsby and other regulars from the St. Louis lineup. The 1926 season would be Hornsby's last one with the Cards. He "slumped" to a .317 average after hitting over .400 in three of the previous four years. He was then traded to the Giants. Hornsby's lifetime batting average of .358 ranks second on the all-time major-league list. (Courtesy St. Louis Cardinals.)

OFFICIAL BOX SCORE

Erie.	ab.	r.	h.	o.	a.	e.	St. Louis.	ab.	r.	h.	o.	a.	e.
Peorl, s.s.	5	0	0	2	3	2	Holmes, s.s.	5	0	1	1	1	0
Fleming, l.f.	4	0	0	2	2	1	Southworth, r.f	5	0	1	1	0	0
Layden, c.f.	3	0	2	2	0	0	Flowers, 2b	4	0	1	2	0	1
Paskert, r.f.	3	0	1	1	0	0	Hafey, 1b	4	1	2	3	0	0
Ward, 3b	3	0	1	1	2	0	Douthit, c.f.	4	2	1	1	0	0
Bible, 2b	2	1	0	0	4	0	Toporcer, 3b	4	0	1	1	0	1
Moske, 1b	3	1	1	8	2	0	Warwick, c	4	1	3	18	0	0
O'Connell, c	2	0	0	3	0	0	Clough, l.f.	2	0	0	0	0	0
Munch, c	2	0	0	7	0	0	Hallahan, p	4	0	1	0	0	0
Berry, p	2	0	0	1	1	0	Johnson, l.f.	1	0	0	0	0	0
Webber, p	1	0	0	0	0	0	*Alexander	1	0	0	0	0	0
Henry, p	1	0	0	0	1	0							
Totals	31	2	5	27	15	3	Totals	38	4	11	27	1	2

†Batted for Clough in 6th.

ST. LOUIS	0	2	0	1	0	1	0	0	0—4
ERIE	0	0	0	1	0	0	0	0	1—2

Two-base hits, Layden, Holmes, Douthit, Warwick; three-base hits, Hafey; home runs, Moske, Warwick; left on bases, St. Louis 7; Erie 8; first base on balls, off Hallahan 3; struck out, by Hallahan 15, Berry 3, Webber 4; wild pitch, Hallahan; passed ball, Warwick; hits, off Berry 6 in 4, off Webber 4 in 3, off Henry 1 in 2; umpires, Cohen, Mannix and Daley.

In that 1926 game, the Sailors valiantly battled the Cardinals but wound up on the short end of a 4-2 score. Cardinal pitcher "Wild Bill" Hallahan, a standout member of the St. Louis "Gas House Gang" of the 1930s, struck out 15 Sailors. Erie first baseman Barney Moske connected with a homer to center in the fourth. In Erie's lineup was catcher "Jocko" Munch, who was a key figure in Erie baseball well into the 1950s. Two eventual Hall of Famers appeared for the Cardinals: first baseman Chick Hafey and pinch-hitter Grover Cleveland Alexander.

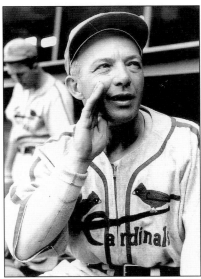

Right fielder Billy Southworth was a steady major-league player from 1913 to 1929, but his greatest achievements came as a manager in the 1940s. From 1942 through 1944, his Cardinals won three straight pennants and took the World Series in 1942 and 1944. He later became skipper of the Boston Braves, winning the AL pennant in 1948. The Braves fell to Cleveland in the fall classic, becoming the last team lose a World Series to the Indians. (Courtesy St. Louis Cardinals.)

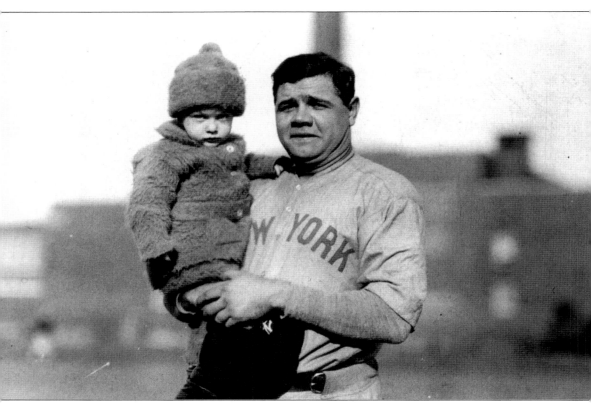

The ever-popular George Herman "Babe" Ruth came to Erie twice for exhibition contests. The Bambino headlined Ruth's All-Stars in a clash against the Erie Moose Club on October 28, 1923. The Stars, behind the pitching and hitting of Dodger southpaw Dutch Ruether, vanquished the Moose, 15-1. Ruth, playing first base, committed two errors but stroked two singles and a home run (which, contrary to popular lore, did *not* clear the Roosevelt School chimney). During pregame activities, according to Jack Kastner of the *Erie Dispatch-Herald*, "Ruth pasted several over the right-field wall, one going over the brick smoke stack on Roosevelt School, and another going so far in the air that it was difficult to say whether it landed on top of the building or passed completely over." The identity of the youngster in this photograph is disputed. He was originally thought to be Tom Carney, son of Jim Carney. A later account identifies the boy as the nephew of local barber Emil Dinges.

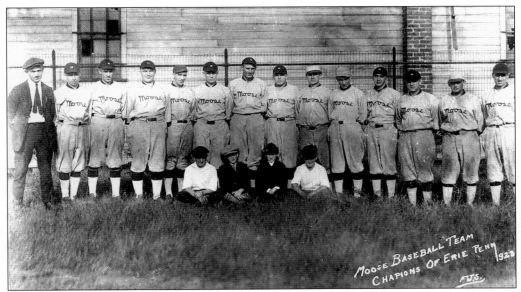

The 1923 Moose Club won the Erie city league championship. Members are, standing from left to right, manager Bert Boland, Elmer Burns, F. Lord, I. Hetico, P. Burick, P. Panitzke, A. Dahlin, J. Hetico, ? Murray, B. Baetzhold, J. Holdenack, F. Detzel, Eddie Burns, and A. Barney. Dahlin surrendered 17 safeties to Ruth's All-Stars in the late-October 1923 game played at Athletic Field. (Courtesy Gannon University Library Archives.)

The 1932 Erie Central League team was a minor-league affiliate of the Yankees. Ruth, Gehrig, and company, sporting an AL-leading record of 75-35, visited the Sailors on August 11. The visitors were defeated, 7-4, before a crowd of 3,000 at Athletic Field. Erie pitchers Luther Gates, Cy Waterman, and Marvin Duke whiffed 10 New Yorkers. Catcher Will Hershberger scored three runs, and first baseman Babe Hadder hit the game's only home run. The 37-year-old Ruth was hitless in four at-bats. The Sailors finished the season in second place, as pitcher Marvin Duke won 23 games and lost only 4.

BOX SCORE

YANKEES

	Ab.	R.	H.	O.	A.	E.
Farrell, 2b	4	2	3	1	1	0
Lary, ss	4	1	1	1	1	1
Ruth, 1b	4	0	0	8	1	0
Gehrig, rf	5	0	2	1	0	0
Chapman, cf	4	0	2	3	0	0
Crosetti, 3b	2	0	0	1	1	1
Hoag, 3b	2	0	0	0	0	0
Byrd, lf	3	0	0	1	0	0
Jorgens, c	4	0	1	8	0	0
Devens, p	2	1	0	0	3	1
Totals	34	4	9	24	7	3

ERIE

	Ab.	R.	H.	O.	A.	E.
McCloy, 3b	4	0	1	0	0	0
Leishman, ss	2	0	0	2	1	0
Holland, rf	5	0	0	2	0	1
Young, cf	3	1	0	1	0	0
Hershberger, c	3	3	2	10	1	0
Hewitt, lf	4	1	3	1	0	0
Hadder, 1b	4	1	2	9	1	0
Henzes, 2b	4	1	2	2	5	0
Gates, p	2	0	0	0	0	0
Waterman, p	1	0	0	0	0	0
Duke, p	0	0	0	0	0	0
Totals	32	7	10	27	8	1

Yankees 200 000 200—4
Erie 031 120 00x—7
Runs batted in—Gehrig 2, Chapman 2, Hadder 4, Leishman. Two-base hits—Jorgens, Hewitt. Home run—Hadder. Sacrifices—Leishman, Waterman. Double plays—Henzes to Leishman to Hadder, Devens to Ruth to Jorgens. Left on bases—Yankees, 11; Erie, 7. Base on balls—Off Devens, 7; off Gates, 3; off Waterman, 5. Struck out—By Devens, 5; by Gates, 6; by Waterman, 4. Hits—Off Gates, 5 in 4 innings; off Waterman, 4 in 4 innings; off Duke, 0 in 1 inning. Balk—Devens. Winning pitcher—Gates. Umpires—Seifert and Daley. Time of game—1:56.

43

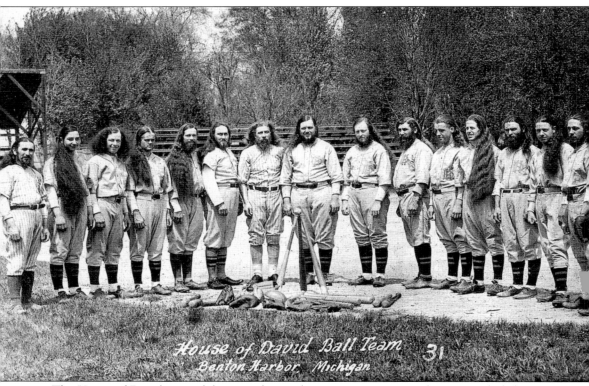

House of David Ball Team 31
Benton Harbor, Michigan

The House of David, one of the most famous barnstorming teams in history, included Erie on its itinerary on July 12, 1935. From the 1920s to the 1950s, teams were sent out across the country by the Michigan-based religious community. The House of David believed its purpose was to gather the lost tribes of Israel; therefore, members (including ballplayers) wore long hair and beards. Its teams were baseball's version of the Harlem Globetrotters, running the bases in reverse, making acrobatic moves in the field, and pioneering the "pepper game," an intricate pregame warm-up routine. To boost attendance (and thus raise more money for the religious group), the club traveled with its own portable lighting system, enabling the team to play night games against local amateur teams.

Championship Baseball

NEWARK EAGLES

Negro National League 1st Half Champions

vs.

CLEVELAND BUCKEYES

Negro American League World Champions

Tuesday Nite, July 23rd

AINSWORTH FIELD 8:00 P. M.

This 1946 newspaper advertisement promotes one of many Negro League games played in Erie. This contest matched two powerhouse teams. Cleveland (Negro American League) won the Negro League World Series in 1945, and Newark (Negro National League) would be the champion the next year. The Buckeyes were owned by Erie entrepreneur Ernie Wright Sr.

Eagles	A	R	H	O	Buckeyes	A	R	H	O
Wilkes,cf	5	1	0	3	Wyatt,ss .	5	0	0	0
Patter'n,3b	5	0	2	3	Wane,1b ..	5	3	3	13
Doby,2b ..	4	2	1	1	Jethroe,2b	4	3	3	3
Irvin,ss ..	4	0	4	0	Kellman,3b	3	1	0	1
Pierson,1b	4	0	0	10	Grace,rf ..	4	0	2	0
Davis,lf ..	4	1	0	1	Armour,cf	4	0	1	3
Harvey,rf	5	0	2	1	Minor,cf ..	0	0	0	0
Parks,c ...	5	0	3	4	Trouppe,c .	3	1	0	4
Manning,p	4	1	1	1	Bremer,p .	4	0	2	1
					Chisim,cf .	4	0	0	2
Totals .	41	5	13	24	Totals .	32	8	11	27

1Batted for Manning in ninth.

Eagles	001	002	020—5	
Buckeyes	208	000	21*—8	

On the evening of July 23, 1946, the Buckeyes defeated the Eagles, 8-5. Sam Jethroe doubled, tripled, and homered. True to his nickname, "The Jet" also stole a base. The Eagles' Monte Irvin banged out four hits. Jethroe, Irvin, Larry Doby, and Quincy Trouppe all played in the major leagues after the "color line" was broken by Jackie Robinson in 1947. Earlier in 1946, Erie's Eddie Klep had joined the Buckeyes; he was the only white player in the history of the Negro Leagues.

Errors—Wilkes, Doby, Chisim, Jethroe. Two base hits — Doby, Wave, Jethroe, Parks, Irvin 2, Bremer. Three base hits—Parks, Jethroe. Home run — Jethroe. Stolen base — Jethroe. Double play—Jethroe and Ware. Left on bases—Newark 12, Cleveland 6. Base on balls—Bremer 4, Manning 1. Struck out—Bremer 4, Manning 2. Hit by pitcher—By Manning (Kellman); by Bremer (Davis. Passed ball — Trouppe. Umpires—L. Cabeloff, G. Cabeloff. Time— 2:28.

October 2, 1874	Philadelphias (NA) defeated Erie Keystones, 25-4
August 26, 1906	Erie Fishermen defeated Pittsburgh Pirates, 4-3
June 11, 1911	Erie Sailors defeated Brooklyn Dodgers, 2-1
July 7, 1913	Erie Sailors defeated Cleveland Naps, 3-2
October 28, 1923	Ruth's All-Stars defeated Erie Moose Club, 15-1
June 29, 1926	Homestead Grays defeated Erie Sailors, 8-3
August 12, 1926	St. Louis Cardinals defeated Erie Sailors, 4-2
August 11, 1932	Erie Sailors defeated New York Yankees, 7-4
July 12, 1935	House of David defeated Erie All-Stars, 16-8
July 8, 1942	Cleveland Indians defeated Erie Sailors, 10-1
July 23, 1946	Cleveland Buckeyes defeated Newark Eagles, 8-5
June 21, 1999	Erie Sea Wolves defeated Anaheim Angels, 10-4

Four
THE CHAMPIONSHIP YEARS
(1938–1951)

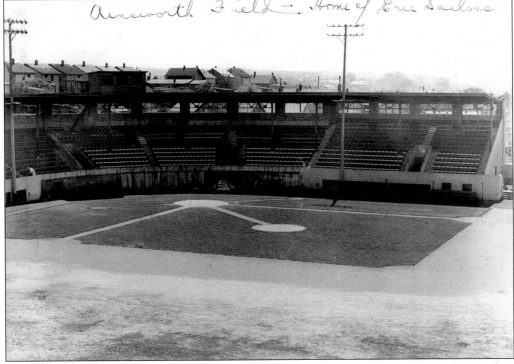

This vintage photograph of Ainsworth Field (West 24th Street and Brown Avenue) was taken from neighboring Roosevelt School. Built in 1920, the ballfield was known as Athletic Field until shortly after World War II, when it was dedicated in honor of James "Doc" Ainsworth, a longtime coach and advisor of Erie's youth. Doc was the physical director of the YMCA (Young Men's Christian Association) from 1915 to 1940. Ainsworth Field was the home of Erie minor-league baseball through the 1994 season. During the following decade, the ballpark fell into disrepair until it was extensively renovated in 2004. Local high school teams will continue to play there well into the future. (Courtesy Betty Peebles.)

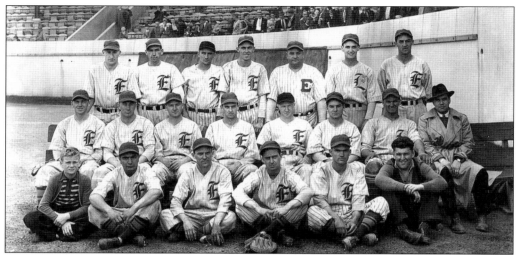

The 1939 Erie Sailors limped home in last place in the eight-team Middle Atlantic League. Lou Stefurak (third row, far right), a southpaw from Homewood, Pennsylvania, compiled a record of 5-15, and settled in Erie, where he worked for several years at Erie Forge and Steel. Al "Moose" Lakeman (second row, seventh from left) was the club's regular catcher. Called up by the Reds in 1942, he was a reserve backstop during his nine-year major-league career. Lakeman returned to Erie in 1959 to manage the Sailors' Pennsylvania–Ontario–New York (PONY) League team. (Courtesy Emily Longo.)

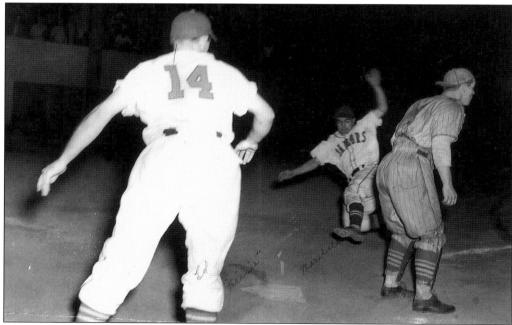

By 1941, night games at Athletic Field were commonplace. Here, Sailors left fielder Hank Marshall slides home safely as teammate Ed Heinrich looks on during a 1941 contest. Erie was a member of the Class C Middle Atlantic League for 10 seasons between 1938 and 1951. League champions five times, the Sailors notched their first title just a few months before the attack on Pearl Harbor. (Courtesy Ed Heinrich.)

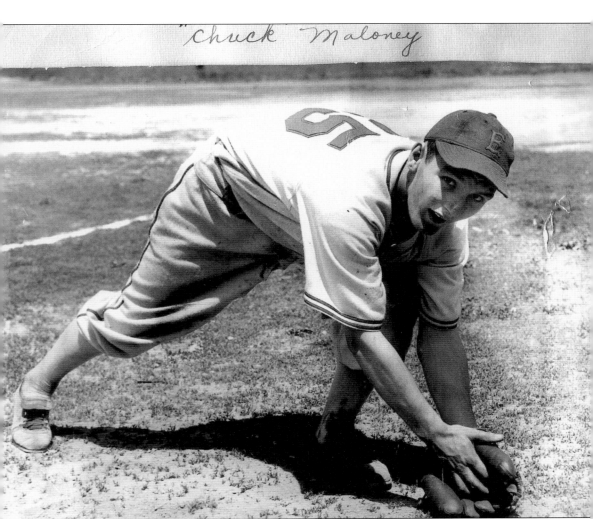

"Chuck Maloney"

Shortstop Chuck Maloney was a key player for the 1941 Middle Atlantic champion Sailors. Maloney batted .249, and the team hit a collective .262. Maloney was promoted to Class A Hartford in 1942, at which point his career was interrupted by World War II. Erie's 1941 team was operated by the Baseball Club of Erie, with Jocko Munch as president, Fred Nash as secretary, and Anthony Keim as treasurer. Among the franchise's directors were Charles Barber and Ray Peebles. The Sailors posted a regular-season record of 75-51. Center fielder Como Cotelle led the club with a .367 average. The 1941 pitching staff was anchored by Red Bertelson (19-8), Jack Barrett (17-9), and Ted Maillet (11-4). (Courtesy Betty Peebles.)

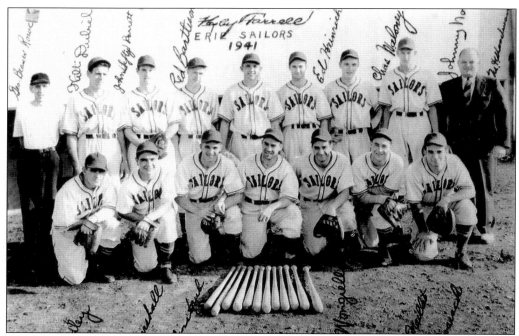

The year 1941 was magical for Erie baseball. The Sailors had dropped out of the Middle Atlantic League after dismal showings in 1938 and 1939. After a hiatus in 1940, the Sailors (affectionately known as the "Gobs") returned and finished the regular season in second place. During the postseason playoffs, Erie took the measure of Springfield, Ohio (led by player-manager Walter Alston, the future Dodger legend), and Dayton, bringing home the league crown. The Sailors were led by Kerby Farrell (second row, fifth from left), who served as manager, first baseman, and pitcher. (Courtesy Ed Heinrich.)

Pitcher Walt Dubiel spent part of his 1941 season with the Sailors. Three years later, "Monk" hurled 19 complete games for the New York Yankees on his way to a 13-13 record. Dubiel's big-league career was hindered by hip, back, and ear problems. His lifetime mark of 45-53 included 9 shutouts. (Courtesy Ed Heinrich.)

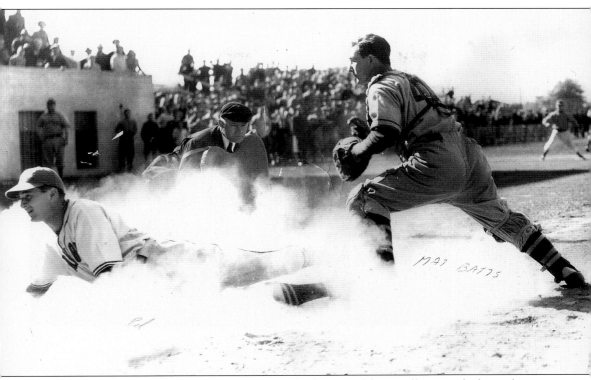

In a cloud of dust, right fielder Ed Heinrich slides home safely to tally a run before a large Athletic Field crowd. Opposing catcher Matt Batts appears to be searching for the ball as the home plate umpire (note his external "balloon" chest protector) eyes the play. Batts, a native of San Antonio, eventually put in 10 major-league seasons (1947–1956) with several teams, chiefly the Red Sox and Tigers. Heinrich was one of the best players to ever don an Erie Sailors uniform. He reached the high minor leagues, competing with and against the likes of slugger Ted Kluszewski and future Pittsburgh Pirates manager Danny Murtaugh. (Courtesy Ed Heinrich.)

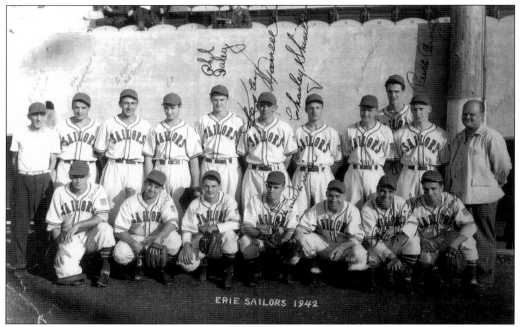

ERIE SAILORS 1942

In 1942, the defending Middle Atlantic League champs stumbled to a fourth-place finish, with a regular-season record of 63-65. But Erie caught fire during the playoffs, besting Dayton and Canton to reclaim the title. Como Cotelle (first row, fifth from left), Ed Heinrich (second row, fourth from left), and Kerby Farrell (second row, sixth from left) returned to lead the team. Farrell batted .276 and posted a 7-1 pitching record. Paul LaPalme (first row, sixth from left) reached the majors with Pittsburgh in 1951. (Courtesy Ed Heinrich.)

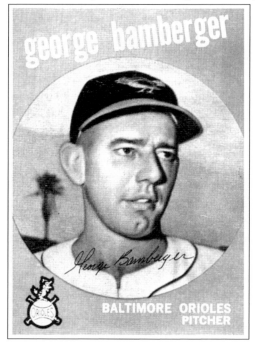

In 1946, the Sailors boasted an awesome pitching staff led by John Uber (18-4), Sam Webb (18-6), and George Bamberger (13-3 with a league-leading 1.35 ERA). Bamberger's greatest success came as a pitching coach and manager. He helped build Baltimore's rotation of Palmer-McNally-Cuellar-Dobson, each of whom won at least 20 games in 1971. In 1978, he was named American League (AL) Manager of the Year, leading the Milwaukee Brewers ("Bambi's Bombers") to a 93-69 record. (Courtesy Topps Company.)

The 1946 Sailors were quite possibly Erie's greatest minor-league team. With outstanding pitching and solid hitting, the Sailors coasted to a record of 91-39. Steve Rushnock (11-3) tossed a regular-season no-hitter at the Youngstown Gremlins. In the first round of the playoffs, Erie defeated Youngstown three games to one. The finals were a nail-biter, with the Sailors outlasting Niagara Falls four games to three. Game 7 was won at home by a score of 14-12. A five-run, eighth-inning rally proved decisive for the "Gobs" in a wild game that produced 33 hits and 11 errors. This was Erie's third consecutive Middle Atlantic League championship. (Courtesy Ed Heinrich.)

Minor-league baseball was in its heyday in the 1940s, both in Erie and across the nation. Local teenager Pearl Martin was one of the Sailors' biggest fans. In 1947, she photographed team members such as Erie favorite Ed Heinrich. (Courtesy Pearl Martin.)

The workhorse of the 1947 Erie pitching staff was Egon Feuker. On May 27, he pitched 18 innings in a 5-4 victory over Vandergrift. He led all Middle Atlantic League pitchers in wins (18) and ERA (2.81). (Courtesy Pearl Martin.)

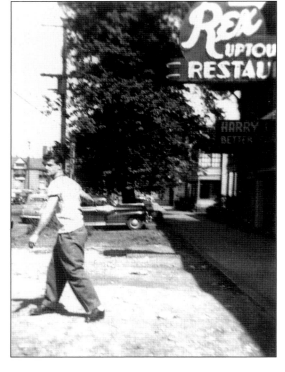

Second baseman Chuck Pepio is pictured outside the Rex Uptown Restaurant. Pepio batted just .224, but he was adept in the field. The Rex was located at West 16th and Walnut Streets in Erie's Little Italy, just a few blocks from Ainsworth Field. (Courtesy Pearl Martin.)

Mike Colombo patrolled the outfield at Ainsworth Field for the Sailors in 1947. One of the team's offensive stalwarts, Colombo batted .362 and rapped out 34 doubles. Fellow outfielder Bill Pavlick hit 13 triples and 18 homers, batted .325, and knocked in 100 runs. Erie was led by manager Don Cross, with Jocko Munch again at the helm as team president. A working agreement with the New York Giants remained in place. The Sailors finished the campaign with a 68-56 record, good for third place. In the first round of the playoffs, Erie was swept by the Vandergrift Pioneers, the eventual league champions. (Courtesy Pearl Martin.)

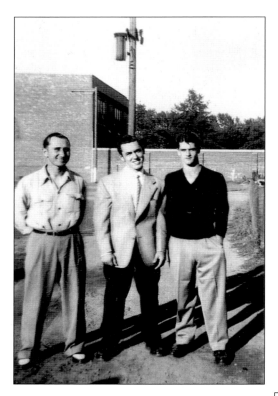

Ah, to be young and a Sailor! This dapper trio looks ready for a night on the town in this August 31, 1947 photograph. Third baseman and manager Don Cross appears on the left, with outfielder Roy Hroncich (center), and second baseman Chuck Pepio. Cross batted .308 and led the team with 98 runs scored. (Courtesy Pearl Martin.)

Shortstop Ziggy Jasinski was the Erie Sailors' "Iron Man" in 1947 and 1948, playing all 124 games each year while leading his club in at-bats. He hit .253 in 1947 and .281 the following season. (Courtesy Pearl Martin.)

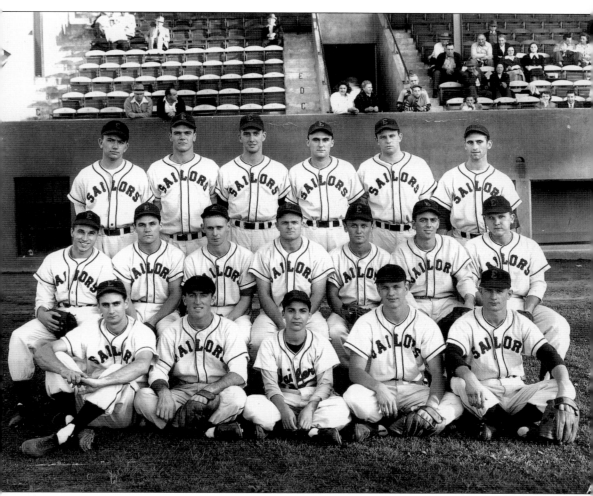

The 1948 Sailors once more "returned the hardware" to Erie, again with a remarkable postseason performance. The team's 80-44 record was good for second place in the final standings. Erie then sailed through the playoffs, sweeping Johnstown and Vandergrift. The Sailors were led by outfielder and Most Valuable Player (MVP) Bill Henry (first row, second from left), who hit .333 and drove home 96 runs. Three hurlers combined for a 49-16 record: Wally Cox (third row, fifth from left), Hugh Oser (third row, third from left), and Bob Hansen (second row, third from left). In 1949, Erie claimed its fifth Middle Atlantic League title in six seasons, besting the Johnstown Johnnies in the championship series. The 1951 season was the last for the Middle Atlantic League. In that year the Sailors posted an impressive 85-40 record, including a 21-game winning streak. However, Erie was defeated in the championship series by the Niagara Falls Citizens, four games to two. (Courtesy Betty Peebles.)

Erie Minor-League Team Records 1928–1951

Year	Name	League	Affiliate	Record	Manager
1928	Sailors	Central	—	76-57	B. Wetzel
1929	Sailors	Central	—	78-61	J. Munch
1930	Sailors	Central	—	76-62	J. Munch
1932	Sailors	Central	New York (AL)	85-56	A. Bender, et al.
1938	Sailors	Middle Atlantic	Boston (NL)	52-75	J. Munch
1939	Sailors	Middle Atlantic	Cincinnati (NL)	55-73	J. Munch
1941	* Sailors	Middle Atlantic	—	75-51	K. Farrell
1942	* Sailors	Middle Atlantic	—	63-65	K. Farrell
1944	Sailors	PONY	New York (NL)	61-63	B. Harris
1945	Sailors	PONY	New York (NL)	46-77	B. Harris
1946	* Sailors	Middle Atlantic	New York (NL)	91-39	S. Mizerak
1947	Sailors	Middle Atlantic	New York (NL)	68-56	D. Cross
1948	* Sailors	Middle Atlantic	New York (NL)	80-44	D. Ramsey
1949	* Sailors	Middle Atlantic	New York (NL)	85-53	P. Pavich
1950	Sailors	Middle Atlantic	New York (NL)	63-52	P. Pavich
1951	Sailors	Middle Atlantic	New York (NL)	85-40	P. Appleton

* — League champions

Five

NATIVE SONS AND
HOMETOWN HEROES
(1954–1967)

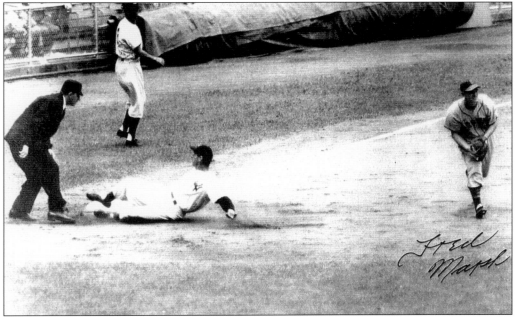

Corry's Fred Marsh played major-league ball for seven seasons as a utility infielder with the Indians, White Sox, Orioles, St. Louis Browns, and Washington Senators. In this 1951 photograph, he fields an errant throw as Yankee Joe DiMaggio slides safely into third base. Marsh's 1951 Browns won only 52 games, and the home attendance that season was a mere 239,790. By 1954, the Browns had moved to Baltimore. Fred rejoined his former teammates, now known as the Orioles, in 1955. He retired in 1956 with a lifetime .239 batting average. (Courtesy Fred Marsh.)

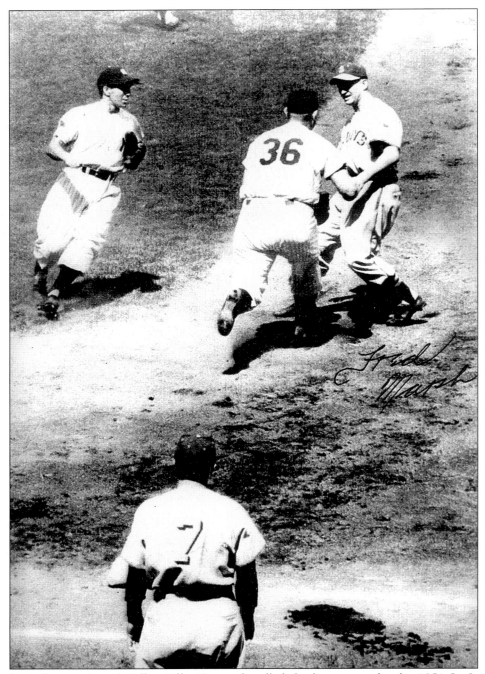

Fred Marsh, a native of Valley Falls, Kansas, handled the hot corner for the 1951 St. Louis Browns. His teammates included the legendary Satchel Paige, future *General Hospital* actor Johnny Berardino, and three-foot-seven-inch Eddie Gaedel. Signed as a publicity stunt by owner Bill Veeck, Gaedel drew a walk in his only big-league plate appearance. Here, Marsh is tagged out by Yankee Johnny Mize as Phil Rizzuto and coach Berardino (No. 7) look on. Fred settled in the Erie County community of Corry and still resides there. (Courtesy Fred Marsh.)

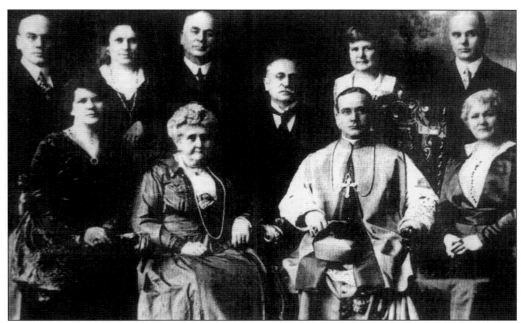

Taken in August 1920, this photograph features newly installed Bishop John Mark Gannon and his family. In the second row, at far right, is the bishop's brother, James "Gussie" Gannon, a fine left-handed pitcher. In fact, Bishop Gannon stated that without the left arm of his brother paying for his education, he never could have become a priest. Gussie pitched in just one major-league game (with Connie Mack's 1895 Pittsburgh Pirates) but had a successful minor-league career in cities such as Buffalo, Rochester, Montreal, and Ottawa. (Courtesy *Lake Shore Visitor*.)

Cliff Melton was born in Brevard, North Carolina, in 1912. The mild-mannered southpaw was a guitar-playing balladeer, earning him the nickname "Mountain Music." For the 1932 Sailors, Melton notched six victories in eight decisions. Joining the New York Giants in 1937, the rookie was a 20-game winner and led the NL with seven saves. He remained with the Giants until 1944, when an arm injury ended his career. (Courtesy National Baseball Hall of Fame.)

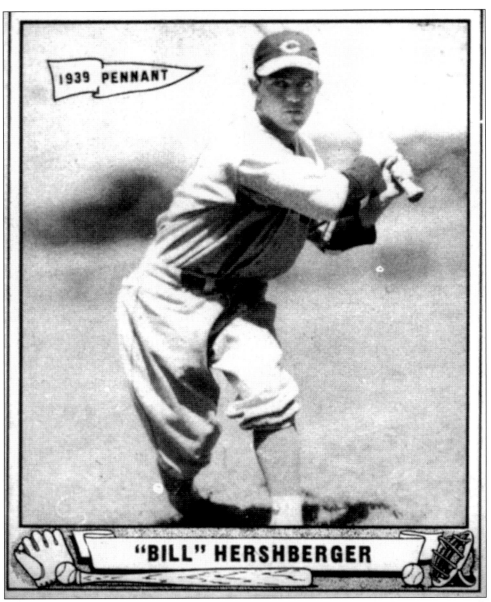

"BILL" HERSHBERGER

Willard Hershberger was the central figure in one of major-league baseball's greatest tragedies. A native Californian, Bill was a Central League All-Star catcher with Erie in 1932, hitting .339. Called up by Cincinnati in 1938, he was a solid contact hitter, backing up future Hall of Famer Ernie Lombardi. Though popular with fans and teammates, Hershberger, haunted by his father's 1928 suicide, could be quiet, depressed, and paranoid. In late July 1940, Lombardi sustained a severe ankle injury, thrusting Hershberger into the role of regular catcher. He played well but blamed himself for his team's losses. On August 3, he failed to report for a doubleheader against the Braves. A team official went to the catcher's room at Boston's Copley Hotel and found Hershberger—the 30-year-old had slit his throat with his roommate's razor. Cincinnati eventually won the 1940 World Series. Hershberger's teammates voted that a full share of the prize money be sent to his mother.

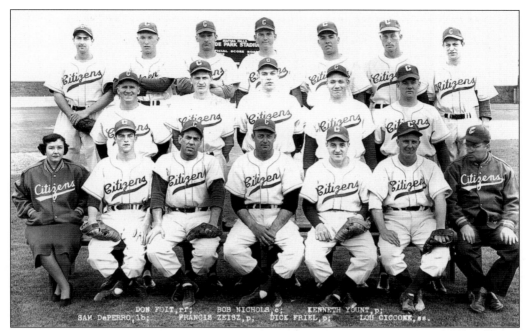

In 1951, Erie played in the Middle Atlantic League. One of its chief rivals was Niagara Falls, an affiliate of the Philadelphia Phillies. Ed Smrekar (first row, second from left), a native of Venus (near Oil City), posted a 9-7 record for the Citizens. Niagara Falls won the league crown, besting the Sailors in the league championship series. After seven seasons as a minor-league hurler, Smrekar retired and made Erie his home. He starred for several years in the Glenwood League, and his Girard team captured the 1964 National Baseball Congress state title. (Courtesy Ed Smrekar.)

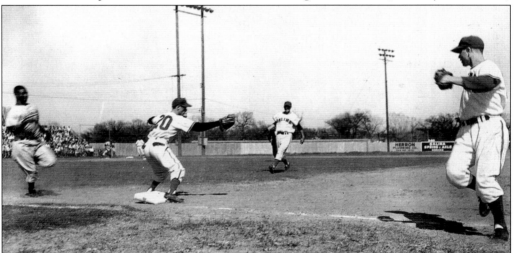

Ed Smrekar (covering first base) was a Western Association (Class B) All-Star for the 1952 Salina (Kansas) Blue Jays. The diminutive left-hander dazzled opponents on his way to a 16-9 record. He even notched victories in both games of a twin bill, as reported in the *Salina Journal*: "The peppery southpaw, who pitches, pinch hits, plays outfield, and does everything but the club's laundry, came up with two airtight relief chores as Salina swept a doubleheader from the Topeka Owls 8-7 and 5-4." (Courtesy Ed Smrekar.)

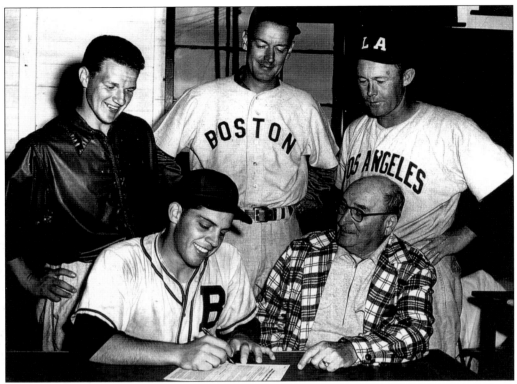

While playing sandlot baseball in Cleveland, Jack Arrigo was spotted by Indians general manager Hank Greenberg. In this 1954 photograph, the 19-year-old catcher signs a contract with the Boston Red Sox as scout Ted McGrew looks on. Standing behind them are, from left to right, Red Sox infielder Ted Lepcio, pitcher Sid Hudson, and veteran catcher Al Evans. Arrigo moved quickly through the minors, with stints at Lafayette, Indiana (Midwest League), Bluefield, West Virginia (Appalachian League), and San Jose (California League). (Courtesy Jack Arrigo.)

During his minor-league years from 1954 to 1957, Jack Arrigo was a rugged, strong-armed backstop. However, while with the Louisville Colonels (American Association), he suffered a right shoulder injury. Months of rest, treatments, and exercise resulted in no improvement. His promising career was thus thwarted by age 23. Arrigo settled in Erie and was a standout performer in the Glenwood League for many years. (Courtesy Jack Arrigo.)

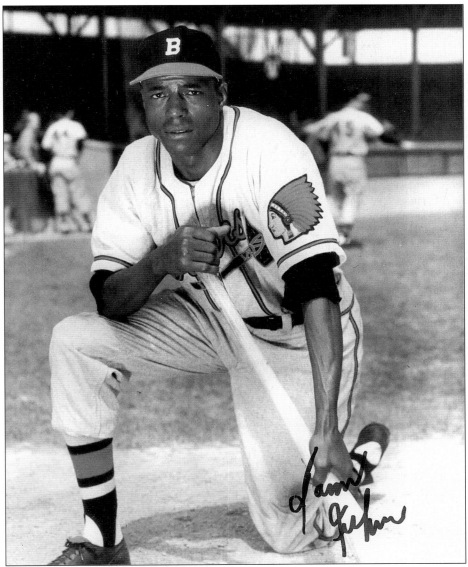

Sam Jethroe, an Erie baseball legend, is an adopted son of the city. He was born in East St. Louis, Illinois, where he played high school football and basketball. He also boxed and played semipro baseball. In 1938 Jethroe entered the Negro Leagues with Indianapolis, and later starred with the Cleveland Buckeyes. The switch-hitting Jethroe had it all—speed, power, and a .342 average in six seasons with the Buckeyes. "The Jet" finally got his chance in the majors in 1950, with the Boston Braves. He was voted NL Rookie of the Year at age 32, leading the circuit with 35 stolen bases that season. Sam settled in Erie in 1942 and became a prominent member of the community. He owned and operated Jethroe's Steak House, and was active with the YMCA). Sam Jethroe died in 2001. (Courtesy Ken Harden.)

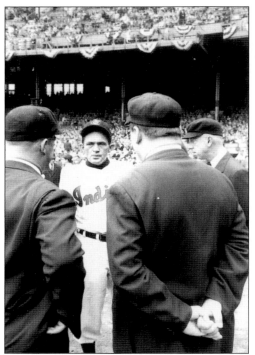

Kerby Farrell honed his managerial skills with the 1941 Middle Atlantic League champion Erie Sailors. In 1957, he was named manager of the Cleveland Indians. In this photograph, Farrell meets with umpires before the Tribe's home opener on April 16, 1957. Cleveland lost to the White Sox, 3-2, and finished the season in sixth place in the American League, with a record of 76-77. This was Farrell's lone season as a big-league skipper. (Courtesy Betty Peebles.)

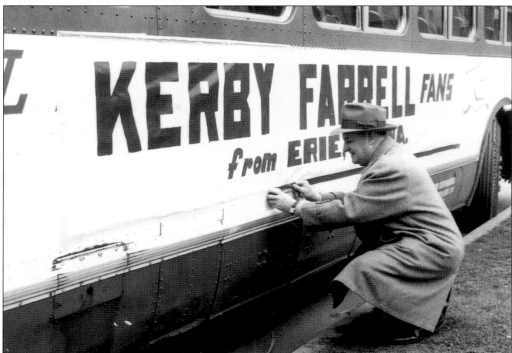

Local friends and fans of Kerby Farrell boarded a bus to cheer him on in his managerial debut with the Indians. Here, longtime Erie sportswriter and baseball executive Ray Peebles attaches a banner to the Cleveland-bound bus. (Courtesy Betty Peebles.)

Joe Riazzi was a standout pitcher for Strong Vincent High School. After posting a 9-0 record in the semiprofessional Glenwood League, Riazzi was signed by Boston Red Sox scout Socko McCreary. His first assignment was with Lafayette (Indiana) of the Class C Midwest League in 1956. (Courtesy Joe Riazzi.)

During 1957's spring training, Joe Riazzi was struck on the right shoulder by a line drive off the bat of future major-leaguer (and eventual National League president) Bill White. Following hospitalization and unsuccessful rehabilitation, Joe was released by the Red Sox. He returned to Erie and closed out his abbreviated professional career with the Sailors. Other Strong Vincent ballplayers were also signed in the early 1950s. Pitcher Neal Zimmerman graduated in 1950 and inked a contract with the Washington Senators. After military service in Korea, he reached the Southern Association in 1956 with the Chattanooga Lookouts. Sammy Williams, signed by the Chicago White Sox, pitched for Waterloo of the Class B Three-I League. An arm injury in 1955 required surgery, and his major-league aspirations faded. (Courtesy Joe Riazzi.)

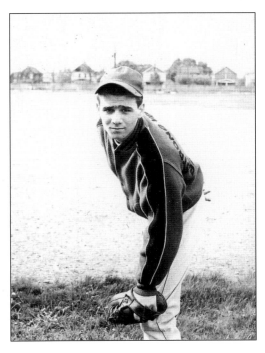

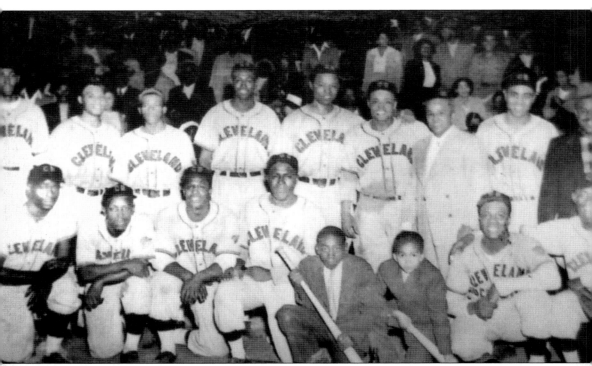

The 1945 Cleveland Buckeyes captured the Negro American League (NAL) pennant and then swept the Negro National League (NNL) Homestead Grays in four games to win the Negro League World Series. The Buckeyes were formed three years earlier through the combined efforts of Erie's Ernie Wright Sr. and Cleveland sports promoter Wilbur Hayes. The 1945 team boasted an outstanding defensive infield and a potent offensive outfield. Several players developed strong ties to Erie. Sam Jethroe led the NAL in stolen bases from 1944 to 1948 and was batting champ in 1944 and 1945. Switch-hitting right fielder Willie Grace was the Buckeyes' MVP in 1946, hitting .305 and playing in both East-West All-Star games. He settled in Erie and concluded his professional career in 1951 with the Sailors. Right-hander Lovell "Big Pitch" Harden posted a 3-2 record and was regarded as the team's best-dressed player off the field. Several other Buckeyes made frequent trips to Erie and Ernie Wright's Pope Hotel, including catcher-manager Quincy Trouppe and pitchers Bill and George Jefferson. (Courtesy Ken Harden.)

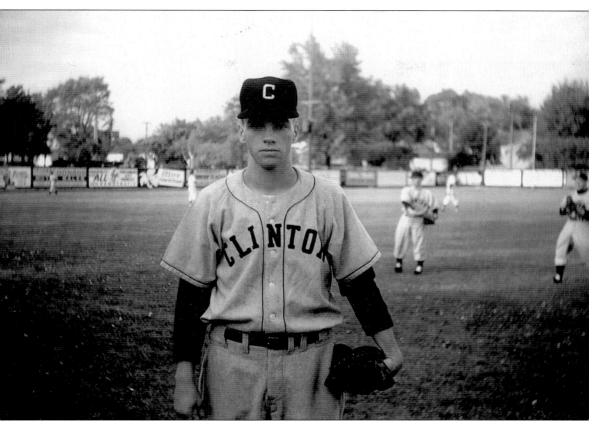

Youngsville native Dallas Haight was signed by the Pittsburgh Pirates following his high school graduation in 1955. A catcher, Haight played his first season with the Dublin Irish in the Georgia State League. The following year, while with Clinton (Iowa) of the Midwest League, Dallas suffered a back injury that cut short his professional career. Thereafter, he lived in Erie and played for several years in the semiprofessional Glenwood League. (Courtesy Dallas Haight.)

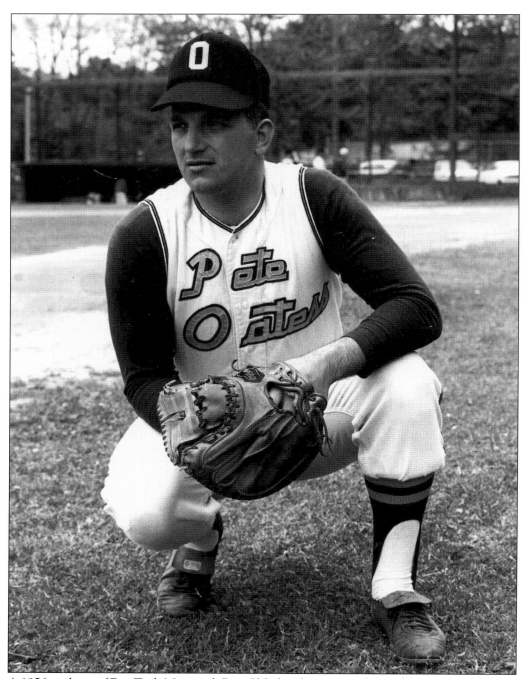

A 1956 graduate of Erie Tech Memorial, Don Chludzinski was a catcher with a potent bat, hitting .560 his senior year. He was signed by the New York Yankees and reported to Kearney in the rookie Nebraska State League. Teammates there included future New Yorkers Deron Johnson and Hal Reniff. The Yanks invited him to join Bradford (New York–Pennsylvania League) for 1957, but "Chlu" declined the offer. He worked for many years at Bucyrus-Erie and played in the Glenwood League for nearly a decade. (Courtesy Don Chludzinski.)

The 1954 PONY League was an eight-team circuit won by the Corning Red Sox. Erie was a Washington farm team, and the Senators logged a sub-.500 record. Catcher Bill LaRosa led the club with 9 triples and 76 RBI. In later years, LaRosa was a Glenwood League participant.

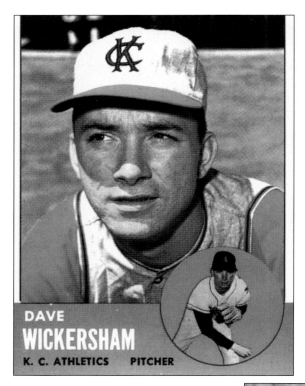

DAVE
WICKERSHAM
K. C. ATHLETICS PITCHER

East Springfield's Dave Wickersham was originally signed by the Pittsburgh Pirates in 1955, under the watchful eye of Branch Rickey. He debuted with the Kansas City Athletics in 1960. After the 1963 season, he was traded to Detroit in a deal that sent Rocky Colavito to the A's. On October 1, 1964, as Wickersham was seeking his 20th victory of the campaign, umpire Bill Valentine got into a heated argument with first baseman Norm Cash. "Wick" tapped Valentine on the shoulder to call timeout and was summarily ejected from the game, thereby ending his season at 19-12. Wickersham's big-league career mark was 68-57, with a nifty 3.66 ERA. (Courtesy Topps Company.)

Bob Rodgers was the regular catcher for the 1957 Erie Sailors, batting .295 and leading the team with 80 RBI. The rural-Ohio native played his entire nine-year major-league career with the Angels. "Buck" then managed the Brewers, Expos, and Angels for 13 seasons. (Courtesy Topps Company.)

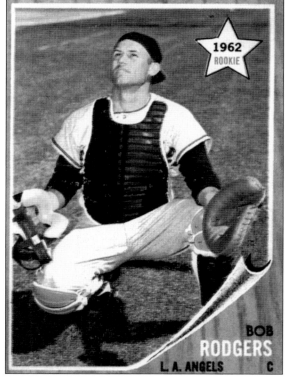

1962
ROOKIE

BOB
RODGERS
L. A. ANGELS C

Pitcher Steve Grilli starred at Erie's Gannon University in the late 1960s. His 1969 ERA of 0.69 was the second lowest in school history. The Brooklyn native pitched for the Detroit Tigers from 1975 to 1977. He is a member of Gannon's Athletic Hall of Fame. (Courtesy Gannon University Athletic Department.)

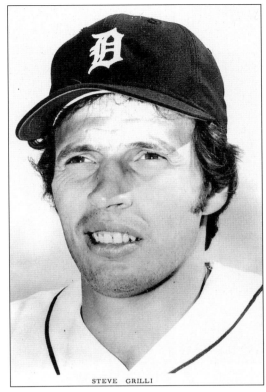

STEVE GRILLI

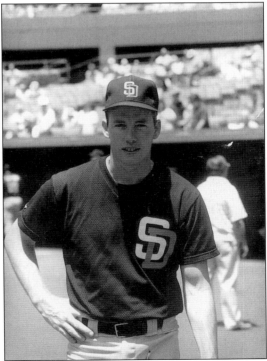

John Costello, a 1983 graduate of Erie's Mercyhurst College, was one of the school's most famous athletes. His career record with the Lakers was 27-9. During his junior year, he posted an ERA of 1.12, the best in the nation. Costello broke into the big leagues with the Cardinals in 1988. He also pitched for Montreal and San Diego, tallying a lifetime record of 11-6. In 1996, he was an inaugural inductee of the Mercyhurst Athletic Hall of Fame. (Courtesy Mercyhurst College.)

Brooks Robinson
— Baltimore Orioles

INVOCATION

OPENING REMARKS

Tommy Helms
— Cincinatti Reds

TOASTMASTER

PRESENTATION

Harry Walker
— Pittsburgh Pirates

INTRODUCTION OF PLAYERS

REMARKS & PRESENTATION

HONORED GUESTS

Dick Radatz
— Cleveland Indians

BENEDICTION

WWYN RADIO
Bart Starr and

Art Arkelian of Erie radio station WWYN brought sports celebrities to Erie for his annual testimonial banquets. This is the lineup from the 1967 program. Special honorees were Roberto Clemente and Bart Starr, the 1966 MVPs of the National League and the National Football League, respectively. Other guests included Brooks Robinson of the Orioles, 1966 NL

AM —

REV. FREDERICK NIES
Pastor, St. Boniface Church

DOUG DAVIS
WWYN Radio Sports

BOB PRINCE
Voice of Pittsburgh Pirates

MAYOR LOUIS TULLIO

BOB PRINCE

ART ARKELIAN
Vice-President—WWYN Radio

BART STARR—ROBERTO CLEMENTE

FATHER NIES

★ **Boyd Dowler**
 — Green Bay Packers

★ **Dick Butkus**
 — Chicago Cubs

★ **Pat Studstill**
 — Detroit Lions

★ **Garo Yepremian**
 — Detroit Lions

elcomes the Friends of
erto Clemente

Rookie of the Year Tommy Helms, Pirate manager Harry "The Hat" Walker, and ace reliever Dick "The Monster" Radatz. More than 600 fans came out on a cold January night to see the star-studded event at Tech Memorial High

A frequent emcee for Arkelian's events was Bob Prince, the voice of the Pittsburgh Pirates. Since Pirate games were carried on Erie radio, the raspy voice of "The Gunner" could be heard from cars and front porches all over town. Later honored with selection to the broadcaster's wing of the Baseball Hall of Fame, he was one of the most colorful characters in baseball.

This drawing of Roberto Clemente appeared in the 1967 WWYN sports banquet program. "The Great One" was coming off one of his best seasons, as the Pirates fell just short of a World Series berth. He won the 1966 NL MVP Award with a .317 average and career-high totals of 29 home runs and 119 RBI. He played six more seasons before his tragic death in a plane crash off the coast of his native Puerto Rico.

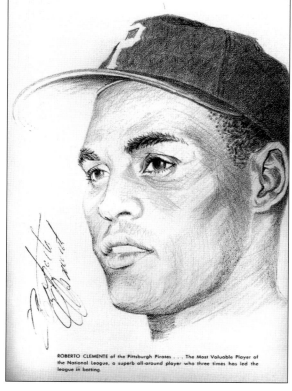

ROBERTO CLEMENTE of the Pittsburgh Pirates . . . The Most Valuable Player of the National League, a superb all-around player who three times has led the league in batting.

The 1957 Erie Sailors finished in second place in the New York–Penn (NYP) League regular season. The team excelled in the playoffs, defeating Batavia three games to two to win the Alice H. Nader Cup. Its star was lanky shortstop Jake Wood, who led the team in batting (.318), home runs (15), and runs scored (93). As a rookie with the 1961 Detroit Tigers, Wood led the American League with 14 triples. He retired after the 1967 season with a .250 lifetime average. (Courtesy Topps Company.)

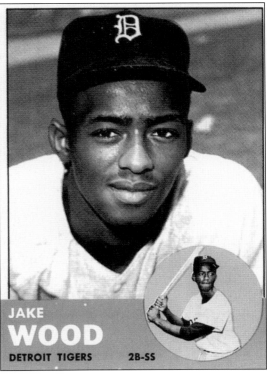

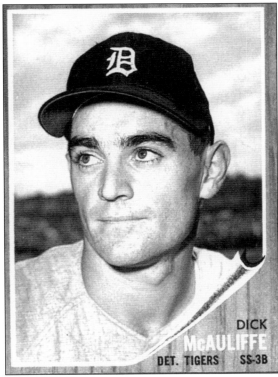

Dick McAuliffe saw limited playing time with the 1957 champion Sailors, hitting .206. However, he later had a distinguished 16-year career in the majors, all but two of those seasons with the Tigers. The three-time American League All-Star middle infielder slugged 197 round-trippers and retired among Detroit's all-time top 10 in five offensive categories. (Courtesy Topps Company.)

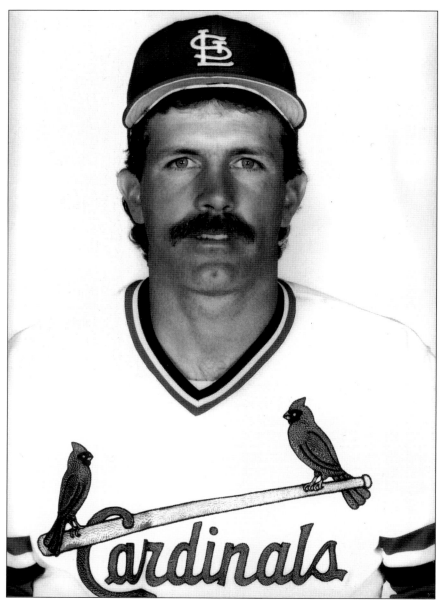

On October 27, 1987, one of Erie's own became an authentic baseball hero. Tom Lawless played for Erie's Strong Vincent High School and Penn State–Behrend before signing with the Cincinnati Reds. He was a 1981 Eastern League All-Star, with season totals of 57 stolen bases, 8 home runs, and 48 RBI. He reached the majors in 1982 but could not shake the label of utility player. In 1987, Lawless was a member of the pennant-winning St. Louis Cardinals but hit only .080. Regular third baseman Terry Pendleton was injured during the World Series, and Lawless was called on to fill the void. Game 4 was tied in the fourth inning when Lawless blasted a three-run homer, sparking the Cardinals to a 7-2 win over the Twins. He stood at home plate, watched the ball disappear, and flipped the bat behind him. It was his only hit of the series. Minnesota defeated the Cardinals in seven games, but Erie has never forgotten the night Tom Lawless made his hometown proud. (Courtesy St. Louis Cardinals.)

The 1962 Sailors compiled a record of 68-51, good for second place in the NYP League. Ted Uhlaender was the team's hitting star, leading the league with a .342 average. Uhlaender later played with the Twins, Indians, and Reds, batting .263 over eight seasons. (Courtesy Topps Company.)

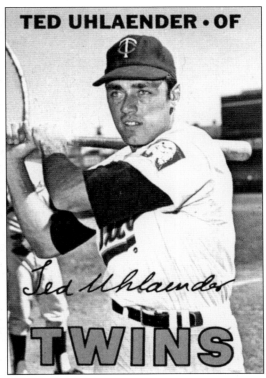

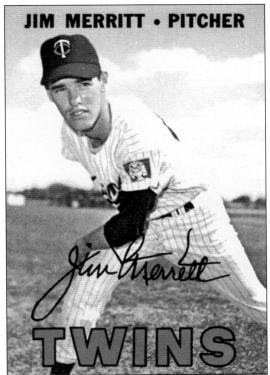

Jim Merritt was voted the MVP of the NYP League in 1962. The Sailors southpaw fanned 249 batters in 223 innings, en route to a 19-8 record. Merritt was a 20-game winner in 1970 for Cincinnati and retired with a lifetime mark of 81-86 in 11 big-league seasons. (Courtesy Topps Company.)

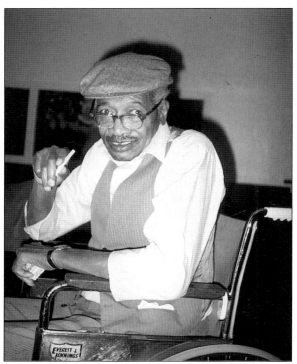

Lovell Harden was born in Laurel, Mississippi, in 1917. A converted catcher, "Big Pitch" joined the Cleveland Buckeyes in 1944, posting a 5-3 record and an ERA of 1.99 in league play. A teammate and close friend of Sam Jethroe, he lived in Erie the last 50 years of his life and was active in the local baseball community. In 1995, Harden, Jethroe, and Willie Grace were guests of the Cleveland Indians to commemorate the 50th anniversary of the Buckeyes' Negro League World Series championship. Harden passed away in 1996 at age 78. (Courtesy Ken Harden.)

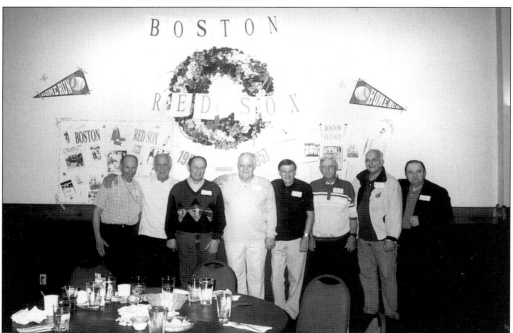

In May 2004, Jack Arrigo was honored on the 50th anniversary of his signing by the Boston Red Sox. Several former minor-leaguers and fellow Glenwood League alums attended. In this photograph, Arrigo is fourth from left, followed to the right by Joe Riazzi, Bill LaRosa, and Don Chludzinski. (Courtesy Marcy Berlin.)

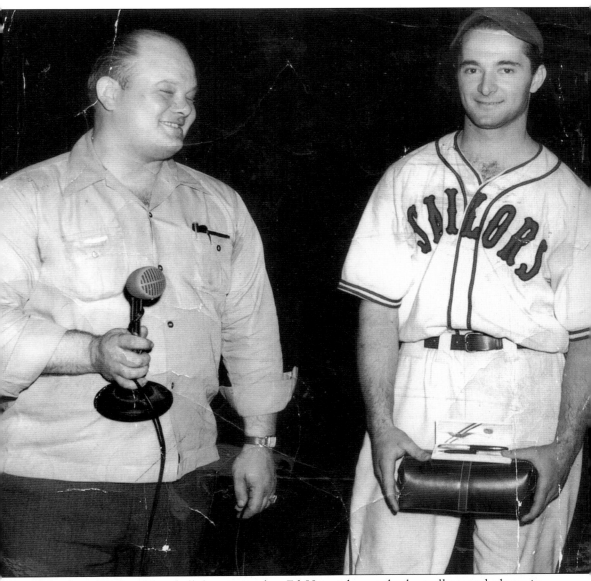

Many longtime local baseball fans insist that Ed Heinrich was the best all-around player in Erie's minor-league history. He played right field for the Middle Atlantic League champion Sailors in 1941 and 1942. Military service during World War II hindered his chances of reaching "The Show," but he starred in the high minor leagues until his professional career concluded in 1951. Heinrich then settled in Erie and became a prominent member of the community. He and his wife, Mary, raised a family in Harborcreek, and he was active in the Erie Boys Baseball Program for nearly 25 years. Heinrich was also a key member of Team Erie, the grass-roots group that worked from 1990 to 1995 to build Jerry Uht Park and keep minor-league baseball in Erie. In 2004, Heinrich actively lobbied for the restoration of Ainsworth Field and helped save the historic ballpark from demolition. Here, he accepts the 1942 Most Popular Sailor Award. (Courtesy Ed Heinrich.)

ERIE MINOR-LEAGUE TEAM RECORDS 1954–1967

YEAR	NAME	LEAGUE	AFFILIATE	RECORD	MANAGER
1954	Senators	PONY	Washington	45-81	T. O'Connell, et al.
1955	Senators	PONY	Washington	66-60	T. Sepkowski
1956	Senators	PONY	Washington	45-74	J. Welaj
1957	* Sailors	NYP	Detroit	70-47	C. Kress
1958	Sailors	NYP	Detroit	53-72	S. Gromek
1959	Sailors	NYP	Detroit	49-76	Lakeman/Mullen
1960	^ Sailors	NYP	Washington	83-46	H. Warner
1961	Sailors	NYP	Minnesota	68-57	H. Warner
1962	Sailors	NYP	Minnesota	68-51	F. Franchi
1963	Sailors	NYP	Minnesota	57-73	F. Franchi
1967	Tigers	NYP	Detroit	26-51	E. Lyons

* — League champions

^ — Playoffs suspended

Six

THE RETURN OF THE
NATIONAL PASTIME
(1981–1994)

The year 1981 meant rebirth for Erie baseball. Ainsworth Field had seen no minor-league ball since 1967, and an entire generation of Erie youth had no hometown team. But a franchise in the short-season New York–Penn League was obtained, and St. Louis became the new major-league parent organization.

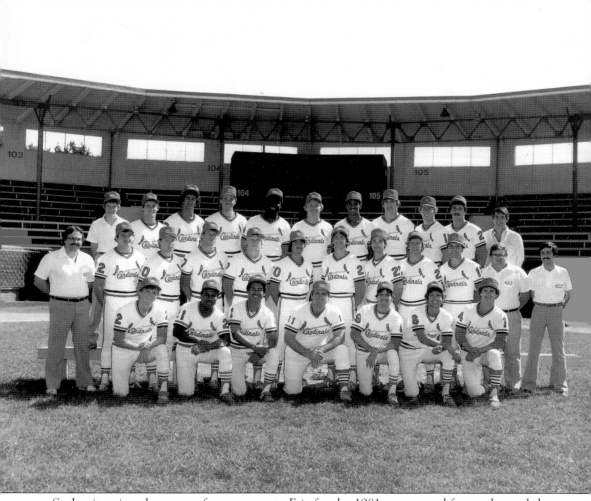

St. Louis assigned a group of young men to Erie for the 1981 season, and fans welcomed them with open arms. For many in the area, this was the first opportunity to watch professional athletes compete. Total attendance for the team's 37 home dates was 76,323, and customers got their money's worth. St. Louis was one of baseball's most successful teams in the 1980s, and local Cardinals fans were privileged to see a large number of future major-leaguers perform in the Flagship City from 1981 to 1987. Appearing in this portrait of the 1981 Erie team are, from left to right, the following (most identified by last name only): (first row) Stryfeller, James, Batista, manager Roger Freed, Menzhuber, Federici, and Hunt; (second row) trainer Caron, Adams, Weems, Finnegan, Dunn, Maldonado, Lyons, Martin, LaRose, Lenny Fatica (radio announcer), and Bill Acevedo (assistant general manager); (third row) Laughlin, Roath, Alba, Thomas, Pittman, Guin, Harris, North, Southern, Parmenter, and Dave Masi (team president). Under Freed's guidance, Erie posted a fine 44-30 record. (Courtesy Betty Peebles.)

Infielder Bill Lyons was the spark plug of the 1981 Cardinals. The NYP League All-Star batted .327, with 65 RBI in only 73 games. He also pilfered 16 bases. His Erie season statistics put him on the fast track to St. Louis, where he played with the Redbirds for the 1983 and 84 campaigns. (Courtesy St. Louis Cardinals.)

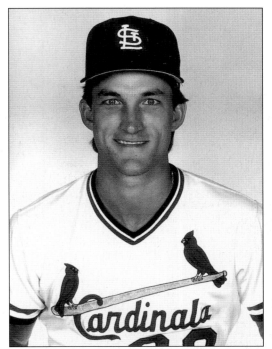

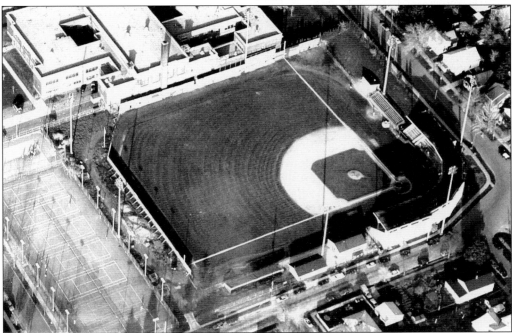

Ainsworth Field, seen c. 1984, was home to Erie's minor-league teams from 1930 through 1994, except for the 1938 season, when contests were played at GE Field. In 1937, a fire resulted in severe damage to the grandstand at Athletic Field (as it was then known), shutting down the facility. Roosevelt School stands beyond the right-field wall. The distance down the right-field line was claimed to be 285 feet; in reality it measured a mere 263. (Courtesy Chet Szymecki.)

A highlight of the 1981 season was the no-hitter pitched by Erie's Greg Dunn. The right-hander from Yakima, Washington, took the hill against the Batavia Trojans. By the seventh inning, anticipation was building with each pitch. Dunn struck out 7, including one to record the 27th out, as the Cardinals prevailed 11-1. He threw an astounding 150 pitches but said afterward, "When it got down to the last six outs, I was really pumped up and never thought about running out of gas."

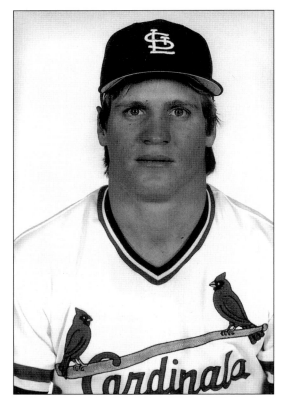

Greg Dunn was named to the 1981 NYP League All-Star team on his way to a record of 7-1. Later in his career, he was converted to a reliever, recording 20 saves in 1985 for Springfield of the Midwest League. Only two other Erie pitchers had ever tossed a no-hitter in the NYP League: John Herbert against Hornell in 1956 and Cubert Smith against Auburn in 1958. (Courtesy St. Louis Cardinals.)

A mainstay of Erie's 1981 club was catcher Randy Hunt, a .297 hitter with eight home runs. An Alabama native, Hunt gradually climbed the Cardinals' minor-league ladder, reaching the majors in 1985. He hit only .158 in 14 games before being traded to Montreal for the 1986 season. (Courtesy St. Louis Cardinals.)

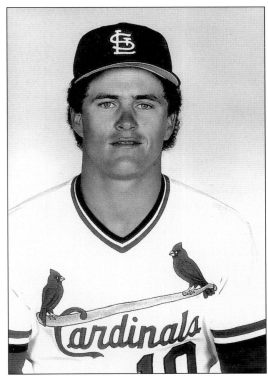

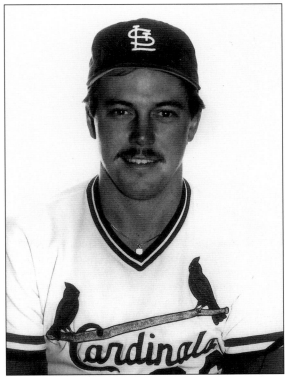

Joe Boever was unheralded when he came to Erie in 1982, signing with St. Louis as an undrafted free agent. But the Kirkwood, Missouri, native made it to the big club in 1985. For 12 seasons, he was a reliable middle reliever for seven organizations. He led the NL with 81 appearances while with the Astros in 1992 and sported a lifetime record of 34-45. (Courtesy St. Louis Cardinals.)

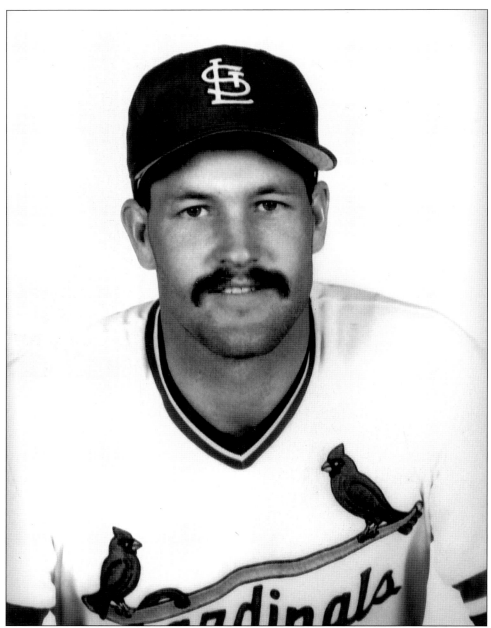

Todd Worrell's professional career began with the Erie Cardinals in 1982. Within four years, he was one of the National League's top closers. He arrived in St. Louis late in its pennant-winning 1985 season. In Game 5 of the World Series, he struck out six consecutive Kansas City Royals. In 1986, he compiled an ERA of 2.08 with an NL-leading 36 saves, good for Rookie of the Year honors. In the 1987 World Series, he saved two of the Redbirds' three victories against Minnesota. Arm problems sidelined Worrell in the 1990–1991 season. He rebounded with the Dodgers from 1993 to 1996, again leading the NL in saves with 44 in 1996. Worrell compiled a total of 256 saves during his 11 years in the majors, while striking out nearly one batter per inning pitched. (Courtesy St. Louis Cardinals.)

Lance Johnson was a 1984 Cardinals sensation. The speedy center fielder batted .339, stole 29 bases, and was selected to the NYP League All-Star team. Johnson played for 14 seasons in the big leagues, retiring after the 2000 season with a .291 lifetime batting average. Johnson is the only player to lead both leagues in hits (with the White Sox in 1995 and the Mets in 1996). (Courtesy St. Louis Cardinals.)

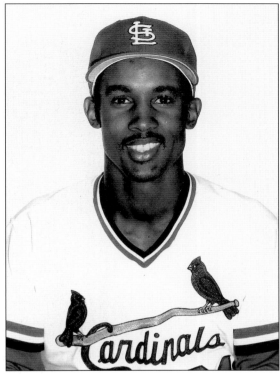

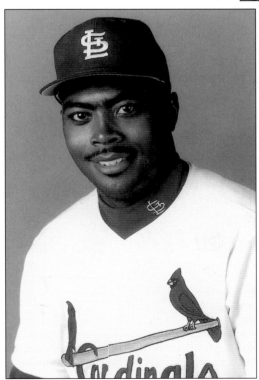

Outfielder Otis Bernard Gilkey was a member of the 1985 Erie nine. He hit only .204, but his 34 steals helped keep him in the St. Louis farm system. A late bloomer, Gilkey was finally called up to his hometown Cardinals in 1990, but his best season was with the Mets in 1996. He retired after the 2001 campaign as a lifetime .275 hitter. (Courtesy St. Louis Cardinals.)

Catcher Tom Pagnozzi was one of the best players of the Erie Cardinals' seven-year era. In Erie's 45-game 1983 season, he hit .310, with 6 homers and 22 RBI. He was called up to the Redbirds in 1987 and remained with St. Louis throughout his 12 years in the majors. Known for his superb defense, Pagnozzi was a two-time Gold Glove winner. A member of the 1992 NL All-Star team, he tied a major-league record by committing only one error in 138 games. (Courtesy St. Louis Cardinals.)

On Sunday, August 4, 1985, the Cardinals hosted the Watertown (NY) Pirates. The visitors' dugout and part of the grandstand can be seen in some detail. Erie's 1985 edition, led by manager Fred Koenig, completed the season with a 44-34 record. The Cardinals won this game 3-1.

Todd Zeile's career began as a 20-year-old catcher with Erie in 1986. The personable Zeile was a fan favorite and led the team with 63 RBI in only 70 games. He even brought fame with him to Erie: his fiancee was gymnast Julianne McNamara, a gold medalist in the 1984 Olympics. As he progressed through the minors, St. Louis touted him as its catcher of the future, prompting Tony Pena to file for free agency. However, Zeile struggled behind the plate during his 1990 rookie season, and he was moved to third base. He remained with the Redbirds until being traded to the Cubs in 1995. During his career, Zeile played with 11 different big-league clubs: the Cardinals, Cubs, Phillies, Orioles, Dodgers, Marlins, Rangers, Mets, Rockies, Yankees, and Expos. He achieved a unique major-league record by hitting at least one home run for all 11 teams. Zeile retired after the 2004 season. (Courtesy St. Louis Cardinals.)

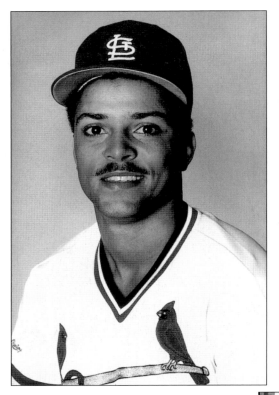

The versatile Luis Alicea has played every position in the major leagues except pitcher and catcher. The fleet-footed Puerto Rican began his career in Erie in 1986, hitting .282 and stealing 27 bases in only 47 games. He reached the majors in 1988 and played for five different teams over 13 seasons, totaling 1,031 hits and a lifetime .260 average. (Courtesy St. Louis Cardinals.)

John Bowen (No. 55 in white) was better known in Erie for his exploits on the basketball court than on the baseball diamond. He was a star performer for Gannon University's Golden Knights, the 1987 NCAA Division II runner-up. Bowen was also a member of the Erie Orioles in 1989, pitching a total of nine innings in his brief professional baseball career. (Courtesy Gannon University Athletic Department.)

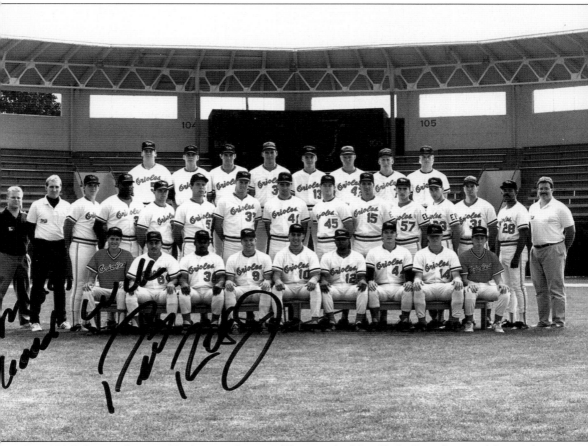

In 1988 Baltimore became Erie's major-league affiliate in the New York–Penn League. Managed by former major-leaguer Bobby Tolan, the 1988 Orioles compiled a 46-31 mark. Tolan (second row, second from right) returned in 1989, but the team (pictured above) struggled to a 25-49 record. Among the team's players was Pete Rose Jr. (first row, eighth from left), whose famous father was banished from baseball in that same summer because of gambling. Pete Jr. led the 1989 Orioles with 13 doubles, while hitting .276. Over the next 15 years he played in 18 cities, including a brief appearance with the Reds in 1997. Another notable player was second baseman Tony Beasley (first row, sixth from left), the team's MVP with 19 steals and a .279 batting average. In 2004 Beasley managed the Eastern League's Altoona Curve. This photograph was contributed by Sean McNerney (first row, far right), one of the Orioles' bat boys.

Erie Minor-League Team Records 1981–1994

Year	Name	League	Affiliate	Record	Manager
1981	Cardinals	NYP	St. Louis	44-30	R. Freed
1982	Cardinals	NYP	St. Louis	35-38	J. Rigoli
1983	Cardinals	NYP	St. Louis	37-38	J. Rigoli
1984	Cardinals	NYP	St. Louis	43-31	R. Hacker
1985	Cardinals	NYP	St. Louis	44-34	F. Koenig
1986	Cardinals	NYP	St. Louis	37-40	J. Rigoli
1987	Cardinals	NYP	St. Louis	36-39	J. Rigoli
1988	Orioles	NYP	Baltimore	46-31	B. Tolan
1989	Orioles	NYP	Baltimore	25-49	B. Tolan
1990	Sailors	NYP	—	44-33	M. Fichman
1991	Sailors	NYP	—	37-41	B. Moss
1992	Sailors	NYP	Florida	40-37	F. Gonzalez
1993	Sailors	NYP	Texas	36-41	D. Sisson
1994	* Sailors	Frontier	—	42-25	M. Fichman

* — League champions

94

Seven
BASEBALL GOES
DOWNTOWN
(1995–2004)

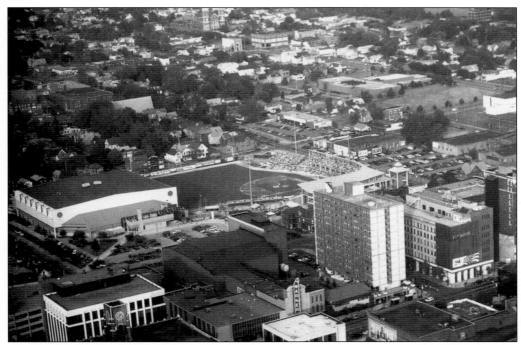

On June 20, 1995, the Erie Sea Wolves and Jerry Uht Park debuted. More than 6,000 people welcomed the return of NYP League baseball and the much-anticipated new ballpark. The city had nearly lost professional baseball because Ainsworth Field no longer met minor-league specifications. But in the early 1990s, Team Erie, under the leadership of Al Swigonski, spearheaded efforts to build a new field in downtown Erie. The field was named after local businessman Jerry Uht, whose generosity helped ensure its place as a gem in the heart of the city. (Courtesy Mike Froelich, Erie Civic Center.)

Thrilled fans enter Jerry Uht Park on opening night, with many already wearing Sea Wolves paraphernalia. Excitement had been building for months as local citizens watched Erie's own "field of dreams" take shape. Especially proud were members of Team Erie, who had worked tirelessly and hopefully for five years. The weather was warm and sunny—a perfect night for baseball! (Courtesy Mike Froelich, Erie Civic Center.)

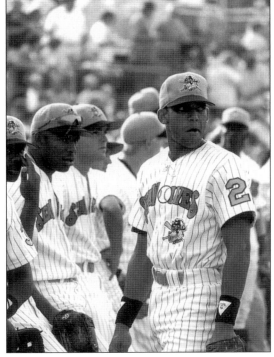

The inaugural edition of the Erie Sea Wolves anxiously awaits the shout of "Play Ball!" For many of the players, this was their first professional game, and opening-night jitters extended far beyond the confines of the new ballpark. These Wolves had come from across the United States, Canada, Puerto Rico, and the Dominican Republic. But they all shared a common dream: to play major-league ball. (Courtesy Mike Froelich, Erie Civic Center.)

Erie mayor Joyce Savocchio addresses the crowd during pregame festivities. Sea Wolves executives, government officials, and local dignitaries were recognized. Mayor Savocchio was instrumental in achieving Erie's goal of constructing a new stadium and bringing back minor-league baseball to the area. (Courtesy Mike Froelich, Erie Civic Center.)

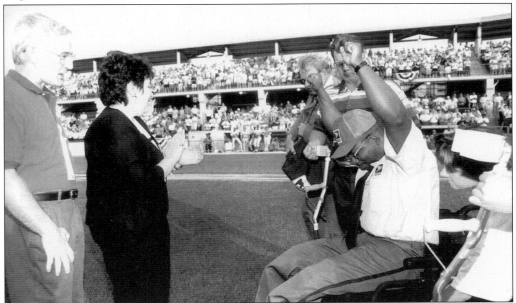

While at work for the United States Postal Service a few months earlier, Erie mail carrier Ron Holman had been severely injured, resulting in the amputation of both legs. Before the opening game, Holman was introduced to the crowd and recognized for his courage, determination, and spirit. (Courtesy Mike Froelich, Erie Civic Center.)

Erie baseball legend Sam Jethroe was acknowledged before the first pitch. His uniform, No. 5, is now displayed on the left-field wall at Jerry Uht Park, taking its rightful place beside Jackie Robinson's No. 42. Both men had been pioneers in the struggle to make major-league baseball a true *national* pastime, open to players of all races. (Courtesy Mike Froelich, Erie Civic Center.)

June 20, 1995, also marked the debut of "C Wolf," Erie's team mascot. "From the woods of Presque Isle", C Wolf delights fans of all ages with his enthusiasm and antics on the field and in the stands. (Courtesy Mike Froelich, Erie Civic Center.)

Sea Wolves outfielder Jose Guillen prepares to swing during Erie's home opener against Jamestown. Born in San Cristobal, Dominican Republic, he had just turned 19 years old. A highly regarded prospect of the Pittsburgh Pirates, Guillen was known for his rifle arm. But on this night, his bat made Jose the first hero of the Erie Sea Wolves. His game-winning home run in the bottom of the ninth inning climaxed a magical evening and helped ignite the postgame fireworks display. By 1997, Guillen was the starting right fielder for the Pirates. (Courtesy Mike Froelich, Erie Civic Center.)

Shortstop Chad Hermansen was Pittsburgh's No. 1 draft pick in 1995. Shortly thereafter, he arrived in Erie with great fanfare. Although erratic in the field, Hermansen showed great promise with the bat. The 18-year-old hit 6 home runs and drove in 25, seemingly making solid contact with every at-bat. However, he was unable to find success with the Pirates, who traded him in 2002. (Courtesy Rich Abel.)

Jose Guillen's ninth-inning blast in the inaugural game at Jerry Uht Park was a preview of big-league success. But his taunting of the opposing Jamestown players (as he rounded the bases) foretold future problems. When the right fielder joined the Pirates in 1997, he was compared to a young Roberto Clemente. But by 1999, Guillen had worn out his welcome in Pittsburgh. He played well for Cincinnati in 2003 and Anaheim in 2004. A late-season dispute with Angels manager Mike Scioscia, however, led to Guillen's suspension and eventual trade to Washington. (Courtesy Rich Abel.)

Tike Redman was just 19 years old when he came to Erie in 1996. Known by his given name of Julian while with the Sea Wolves, the speedy outfielder showed promise by hitting .294. He moved slowly up the Pittsburgh minor-league ladder and came up to stay with the Pirates in 2003. (Courtesy Rich Abel.)

Lefty Joe Beimel was practically a local boy, hailing from nearby St. Mary's. He attended Pittsburgh's Duquesne University and was selected by the Pirates in the 1998 draft. Beimel's first assignment was with the Sea Wolves, but he was an unimpressive 1-4, with an ERA of 6.32. He improved steadily and was in the Bucs' bullpen from 2001 to 2003. In 2004, he joined the Minnesota Twins. (Courtesy Rich Abel.)

Aramis Ramirez showed potential from the very start. For the 1996 Sea Wolves, the youthful third baseman hit .305, with 9 homers and 42 RBI. The muscular Dominican quickly progressed through the minors, becoming a starter for the Pirates in 2001. His .300–34 HR–112 RBI season at 21 years old was remarkable, one of the best offensive seasons ever for a Pirate third sacker. Ramirez slumped in 2002 but rebounded in 2003, only to be traded to the Cubs in a deal that still has Pittsburgh fans scratching their heads. It appears that "A-Ram" will be a fixture at Wrigley Field for years to come. (Courtesy Rich Abel.)

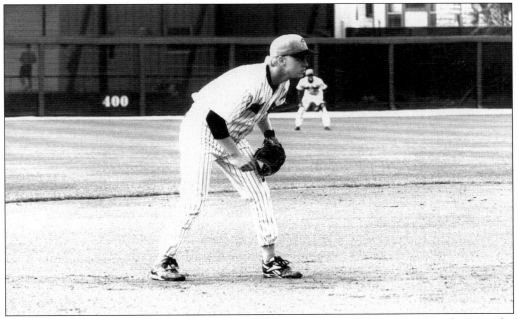

Boomer Whipple had one of the best baseball names ever heard in Erie. He also was the heartthrob of female fans along the left-field line in the summer of 1995. Boomer hit only .253 with two home runs. Nonetheless, his name lives on. (Courtesy Rich Abel.)

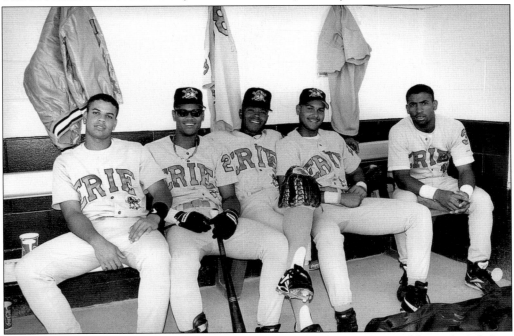

A relaxed group of 1996 Erie Sea Wolves lounges in the dugout. Pictured here, from left to right, are Aramis Ramirez, Alex Hernandez, Xavier Burns, Alex Pena, and Nilson Antigua. Unfortunately, this team finished the season in last place in the NYP League's Stedler Division. (Courtesy Rich Abel.)

Rob Mackowiak was selected by Pittsburgh in the 53rd round of the 1996 amateur draft. He came to Erie in 1997, but his offense did little to enhance his status as a prospect. Rob's versatility in the field then became his ticket to the big leagues. By 2004, his persistence had earned him a regular spot in the Pirates lineup. (Courtesy Rich Abel.)

J. J. Davis, the Pirates' first pick in the 1997 draft, arrived in Erie at the end of that summer. He remained with the Sea Wolves in 1998. A three-sport star in high school, the outfielder hit 8 homers and knocked in 39 runs for Erie in 1998. Much was hoped of the six-foot-four-inch Davis, but his progress was slow. With Pittsburgh for parts of 2002 through 2004, he was traded after the conclusion of the 2004 season. (Courtesy Rich Abel.)

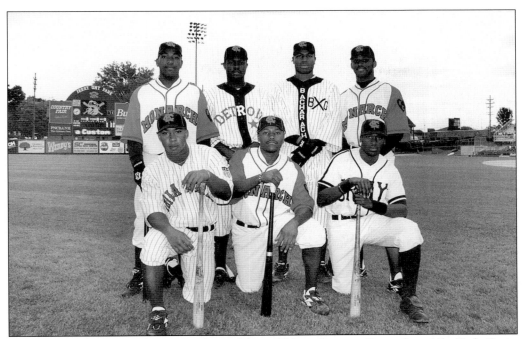

During the 1997 season, the Sea Wolves celebrated Negro Leagues Day at Jerry Uht Park. Team members wore period uniforms for the game. From left to right are the following: (first row) Chris Clark, Xavier Burns, and Terrence Freeman; (second row) Diogenes Diaz, Keith Maxwell, Dawan Elliot, and Corey Pointer. The 1997 team logged a record of 50-26 and won the Stedler Division. Kris Lambert won 11 games to lead the league. (Courtesy Rich Abel.)

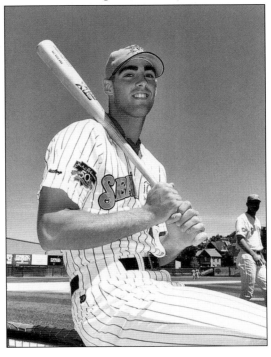

Infielder Kevin Haverbusch was a promising prospect sent to Erie by the Pirates in 1997. He responded by hitting .311 and driving in 55 runs in only 67 games, as he and teammate Derrick Lankford led the NYP League in RBI. But Haverbusch stalled at the AA level and was released by the Pittsburgh organization in 2002. (Courtesy Rich Abel.)

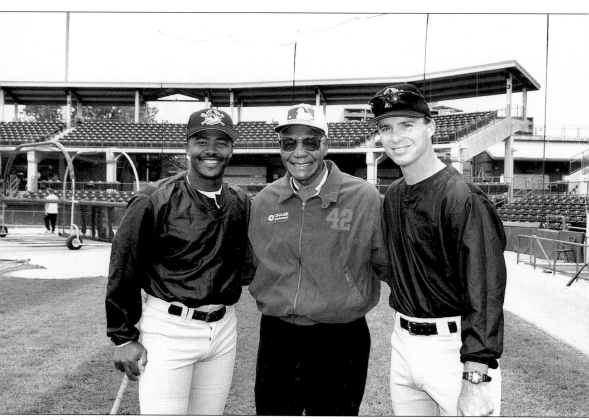

John Jordan "Buck" O'Neill was honored in 1997 at Erie's Negro Leagues Day. Born in Carabelle, Florida, in 1911, Buck has been connected with baseball for seven decades. He was a smooth-fielding first baseman, playing most of his years with the NAL Kansas City Monarchs (1938–1955). After a three-year stint in the U.S. Navy, O'Neill led the NAL in hitting in 1946 (.353). He managed the Monarchs from 1948 to 1955. Buck joined the Chicago Cubs as a scout in 1956, signing future Hall of Famers Ernie Banks and Lou Brock. He then became the first black coach in major-league history when the Cubs hired him in 1962. O'Neill's sparkling commentary in the Ken Burns documentary *Baseball* put the spotlight on this fine gentleman. In recent years, he has served as chairman of the board of the Negro Leagues Baseball Museum. Here, he is flanked by Sea Wolves manager Marty Brown (right) and coach Ramon Sambo. (Courtesy Rich Abel.)

left-hander Mike Johnston had a brief stay in Erie in 1998 after starting the season with Bradenton. He steadily progressed through the minors and joined the Pirates bullpen in 2004. Johnston has successfully overcome Tourette's syndrome, a neurological condition characterized by chronic vocal and motor tics. (Courtesy Rich Abel.)

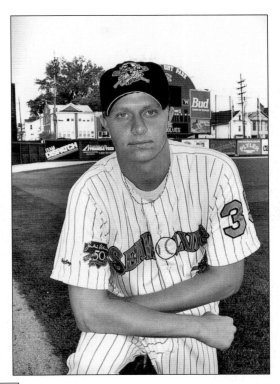

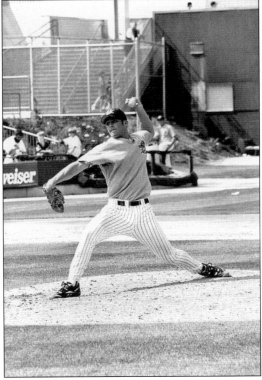

A 19-year-old Dave Williams made an impressive debut with the 1998 Sea Wolves. The southpaw posted a 2-2 record with an ERA of 3.23, walking only 14 in 47 innings. The native Alaskan joined Pittsburgh in 2001. An arm injury required surgery, and Williams missed the entire 2003 campaign. Hopefully, a healthy left arm and good control will lead to a bright future for both him and the Pirates. (Courtesy Rich Abel.)

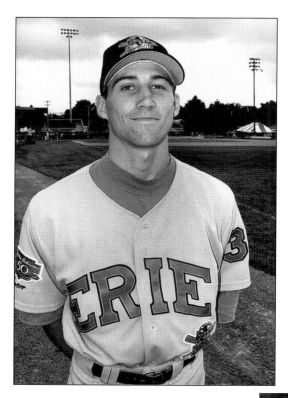

Speedy Kory DeHaan landed in Erie soon after being selected by the Pirates in the seventh round of the 1997 amateur draft. He stole 14 bases for the Sea Wolves, but his bat did not pick up steam until 1998, when he hit .314 for Augusta. Kory reached the majors with San Diego in 2000, but his big-league experience thus far has been limited. (Courtesy Rich Abel.)

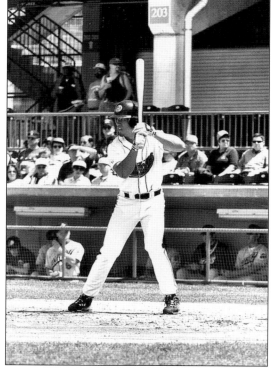

In 1999, the Sea Wolves organization took the giant leap into AA baseball, and the results were spectacular. Anaheim became the new parent club, and the Angels sent a talented team to Erie. The Sailors' biggest offensive star was first baseman Larry Barnes, who led the team in home runs (20) and RBI (100). Performing well at the AAA level, Barnes has seen action with the Angels and Dodgers. (Courtesy Rich Abel.)

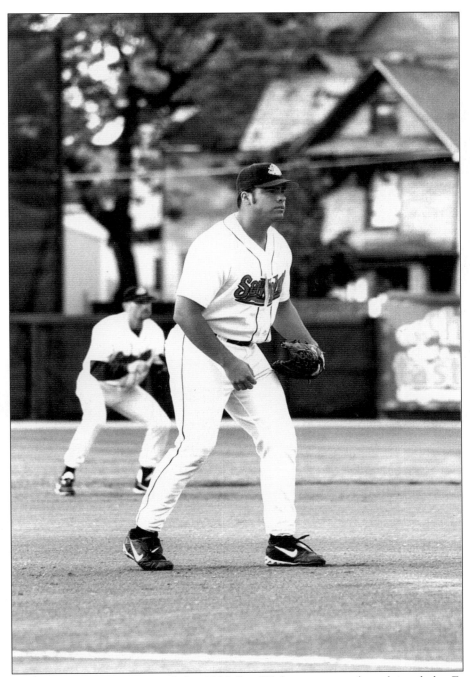

Shawn Wooten was a mainstay of the 1999 Sea Wolves, a team that claimed the Eastern League's Southern Division crown with a record of 81-61. The hard-nosed third baseman and catcher had already spent six years in the minors by the time he reached Erie. He responded with a .292 average, 19 homers, and 88 RBI. Wooten returned to the Sea Wolves in 2000 and was called up by Anaheim later in the season. Shawn earned a World Series ring as a member of the 2002 Angels. He played for Philadelphia in 2004. (Courtesy Rich Abel.)

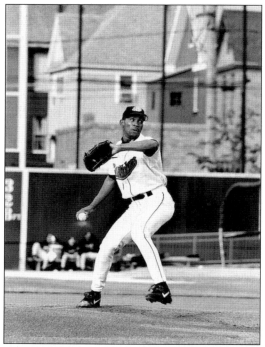

In 1999, pitcher Ramon Ortiz was a highly touted Sea Wolves prospect. Equal to the challenge, the 23-year-old Dominican posted a 9-4 record and a nifty 2.82 ERA. Later in 1999, he was promoted to AAA Edmonton, then to Anaheim. In 2002, the Angels won the American League pennant and defeated the San Francisco Giants in a thrilling seven-game World Series. Ortiz, a 15-game winner during the regular season, was the starting and winning pitcher in Game 3. (Courtesy Rich Abel.)

Erie minor-league players have often lived in the homes of fans in the community. Ramon Ortiz and teammate Juan Tolentino stayed with John and Gina Johnston during the 1999 season. In this "jam session" at the Johnston residence, Ortiz plays the maracas and sings; Tolentino accompanies him on the keyboard. (Courtesy John Johnston.)

Brian Cooper was a standout pitcher for the 1999 Sea Wolves. He pitched 6 complete games and sported a 10-5 record and 3.30 ERA. Cooper was called up to the Angels at the end of 1999, and then posted a 4-8 record for the Halos in 2000. He has also pitched for Toronto and San Francisco. (Courtesy Rich Abel.)

Australian Trent Durrington is one of the best lead-off hitters ever to play in Erie. In 1999, he batted .288 and stole 59 bases in 107 games. He was promoted to Anaheim later that summer and played for the Milwaukee Brewers in 2004. (Courtesy Rich Abel.)

Righty John Lackey was one of the few bright spots for the 2000 Erie Sea Wolves. A second-round draft pick by the Angels in 1999, he arrived in Erie midseason, winning six games. In 2002, Lackey was a rookie with Anaheim and helped the Halos reach the American League playoffs with his 9-4 record. In Game 4 of the American League Championship Series, he pitched seven shutout innings against the Minnesota Twins to record the victory. In the World Series, he defeated the Giants in the seventh and deciding game. Not a bad way to begin a major-league career! (Courtesy Rich Abel.)

Darren Blakely (left) and Nathan Haynes patrolled the outfield at Jerry Uht Park for the 2000 Erie Sea Wolves. The pair had speed on the base paths and in the field. Blakely stole 13 bases and Haynes pilfered 37. Blakely also showed power, blasting 16 homers. In 2004, Blakely played in the White Sox farm system and Haynes in the Giants organization. (Courtesy Rich Abel.)

Pitcher Seth Etherton, the Angels' top draft pick in 1998, quickly reached AA Erie by the following season. The right-hander did not disappoint. He won 10 games for the Sea Wolves and posted an impressive 3.27 ERA. He was called up to AAA Edmonton late in the 1999 season and won five games for Anaheim in 2000. Since 2002, Etherton has played in the Cincinnati organization. (Courtesy Rich Abel.)

Pitcher Scot Shields started 10 games for Erie in 1999. His record was 4-4, with a fine ERA of 2.89 and good strikeout numbers. In 2002, Shields was 5-3 for the eventual world champion Angels. In 2003, he started 13 games for Anaheim and posted an ERA of 2.85. In 2004, he appeared in 60 games and recorded four saves. (Rich Abel.)

In 2001, the Sea Wolves were affiliated with the Detroit Tigers. Erie fielded a strong team that won the Southern Division of the Eastern League. First baseman Eric Munson was an Eastern League All-Star and led the league with 102 RBI. With Detroit in 2004, he slugged 19 homers. Munson is a member of the Jerry Uht Park All-Time team and holds several franchise single-season offensive records. (Courtesy Rich Abel.)

Pitcher Nate Cornejo takes a breather in the dugout during his spectacular 2001 season. The six-foot-five-inch native of Wellington, Kansas, notched 12 victories in 15 decisions for the Sea Wolves. This earned him a promotion to AAA Toledo, where, at the end of the 2001 campaign, the 21-year-old right-hander was in the Tigers' starting rotation. In 2003, he had a 6-17 mark for a Detroit team that completed its season with a dismal record of 43-119. Cornejo has struggled with nagging injuries but should be a solid contributor to the Tigers in the coming years. His father, Mardie, pitched for the New York Mets in 1978. (Courtesy Rich Abel.)

Shortstop Omar Infante was only 19 when he played with the 2001 Sea Wolves. He batted .302, with 27 stolen bases and 62 RBI. The Venezuelan native was called up to the Tigers in 2002. He has remained with Detroit, becoming the starting second baseman in 2004. (Courtesy Rich Abel.)

left-hander Andy Van Hekken was a member of the Sea Wolves from 2001 to 2003. Called up by the Tigers late in the 2002 season, he became the first pitcher in 27 years to throw a complete-game shutout in his major-league debut. On September 3, Andy scattered eight hits in his victory over the Cleveland Indians. (Courtesy Rich Abel.)

Outfielder Andres Torres's promising 2001 season with the Sea Wolves was cut short by a shoulder injury. In 64 games, he hit .294 with 19 steals. However, the injury did not thwart his rise in the Tigers' farm system. He stole 42 bases for Toledo in 2002 and has been called up to Detroit in each of the last three seasons. (Courtesy Rich Abel.)

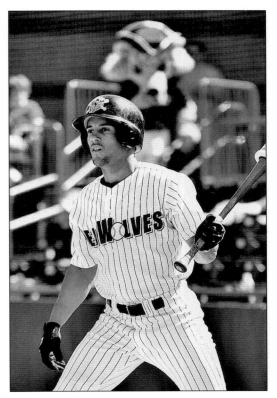

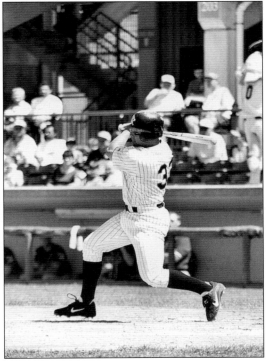

Derek Nicholson, a popular outfielder and designated hitter, has seen action with the Sea Wolves in parts of each season since 2001, and always seems to come up with a clutch hit. Nicholson was selected to participate in the 2004 Olympics as a member of Greece's baseball team but was unable to play. He returned from Athens in August 2004 and played a major role in Erie's drive for the Eastern League playoffs. (Courtesy Rich Abel.)

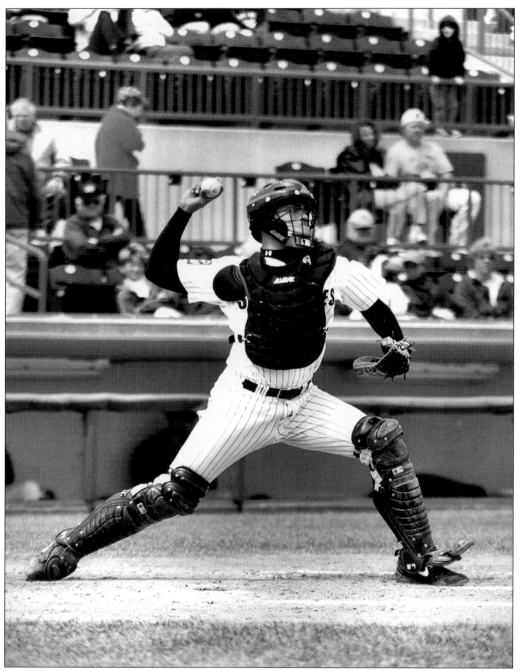

In 2001, catcher Mike Rivera put on an impressive display of power. His 33 home runs led the Eastern League. His 101 RBIs were just one short of the club record (set by teammate Eric Munson). Rivera also captured the highest slugging percentage (.578) in team history. He has played in the majors with Detroit and San Diego. In 2004, he was in the White Sox organization. Unfortunately, Rivera has not been able to reclaim the magic he found in 2001 at "The Uht." (Courtesy Rich Abel.)

Pitcher Kenny Baugh was Detroit's first-round draft pick in 2001 after a stellar career at Rice University. In 2001, he was Pitcher of the Year in the Western Athletic Conference, with an ERA of 1.82. Baugh arrived in Erie with high expectations in the summer of 2001, but a shoulder injury sidelined him for the 2002 season. He worked his way back to the Sea Wolves in 2003 and 2004, showing steady improvement. In 2004, he had a record of 8-8, with an ERA of 3.72. (Courtesy Rich Abel.)

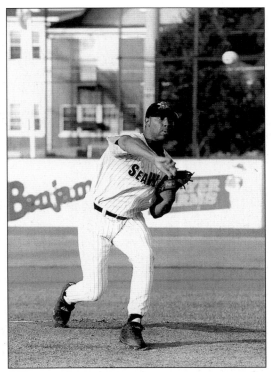

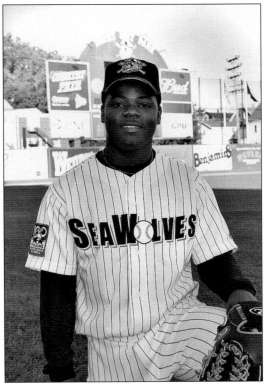

In 2002, Detroit considered Fernando Rodney to be its closer of the future. That year, he had 11 saves for a Sea Wolves team that won only 52 games; he also posted an impressive ERA of 1.33. At midseason he was promoted to Toledo and finished the year with Detroit. More recently, the 22-year-old right-hander missed the entire 2004 season after undergoing "Tommy John" surgery. (Courtesy Rich Abel.)

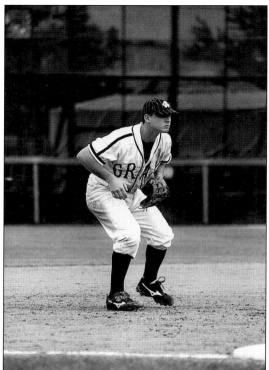

One of the most popular Sea Wolves in recent years is scrappy third baseman Jack Hannahan. In 2004, his third season with Erie, the fans voted him to the Jerry Uht Park All-Time team. A consistent threat at the plate, Hannahan is also a defensive standout at the hot corner. In 2004, he hit .273, with 8 homers and 39 RBIs. (Courtesy Rich Abel.)

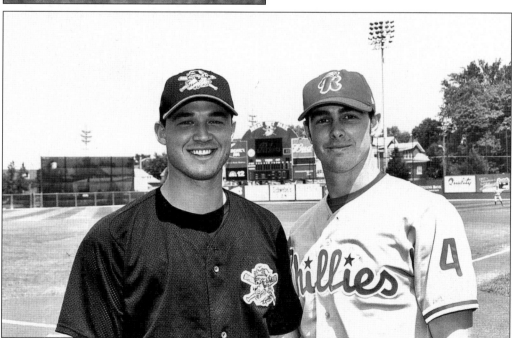

Buzz Hannahan, Jack's older brother, was a regular visitor to Jerry Uht Park as a member of the Reading Phillies. In 2003, the brothers set aside their on-field rivalry to pose for this photograph, with Jack on the left and Buzz on the right. (Courtesy Rich Abel.)

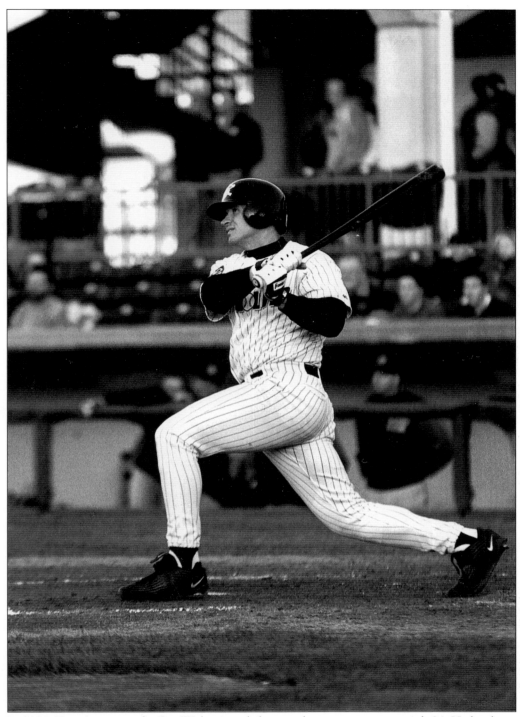

In 2004, Kurt Airoso set the Sea Wolves' mark for most homers in a season with 34. He has been a consistent run producer in each of his three seasons with Erie. Airoso is the all-time Sea Wolves career leader in home runs (68), runs scored (201), and walks (171). (Courtesy Rich Abel.)

Brian Schmack, the most successful closer in Sea Wolves history, is another member of the Jerry Uht Park All-Time team. Named to the Eastern League All-Star team in 2003, he set the single-season Sea Wolves saves record with 29. Schmack appeared in 11 games for Detroit in 2003 and returned to Erie for the 2004 season. (Courtesy Rich Abel.)

Nook Logan's blazing speed was a highlight of the 2003 Sea Wolves campaign. He led the team with 37 stolen bases and kept opposing infielders on their toes with his numerous bunts. Logan earned a trip to Detroit in 2004, and the switch-hitter impressed the Tigers, hitting .278, with 8 steals in 47 games. (Courtesy Rich Abel.)

Catcher Max St. Pierre, a native of Montreal, Canada, played with the Sea Wolves from 2002 through 2004. His sparkling defense behind the plate led to his selection to the Eastern League All-Star team in 2003 and 2004. (Courtesy Rich Abel.)

Team physician Brad Fox has been actively involved in Erie professional baseball since 1992. Dr. Fox has provided medical care to players, coaches, opponents, and umpires. The sports-minded family physician hails from Jamestown, New York, and is a graduate of SUNY-Syracuse School of Medicine. (Courtesy Rich Abel.)

The 2004 Sea Wolves Player of the Year was outfielder Curtis Granderson. He was the Tigers' third-round draft pick in 2002 after an outstanding career at the University of Illinois-Chicago. In his junior year, his batting average of .483 was the second best in the nation. In 2004, Curtis more than justified Detroit's high hopes by having a breakout season in Erie. He hit .301, with 21 home runs, 94 RBIs, and an on-base percentage of .405. Heading into the 2005 season, *Baseball America* has rated Granderson the No. 1 prospect in the Detroit organization. (Courtesy Rich Abel.)

Pitcher Kyle Sleeth was Detroit's first pick in the 2003 draft after an outstanding college career at Wake Forest. He recorded 26 consecutive victories to tie an NCAA record. His overall record was 31-6, including a perfect 14-0 mark in 2002. In 2004, Kyle advanced to Erie for the second half of the season and showed signs of a bright future. While still adjusting to professional baseball, he recorded a 4-4 mark in 13 starts. (Courtesy Rich Abel.)

Ryan Raburn was a fifth-round draft pick for the Tigers in 2001, but his career almost came to an end after an all-terrain-vehicle accident. In 2004, the second baseman proved he was healthy again, batting .301. He also showed good power, hitting 16 home runs and knocking in 63 runs. The Tigers rewarded him with a call up to the majors in September. (Courtesy Rich Abel.)

left-hander Wil Ledezma overmatched Eastern League batters in 2004 and moved directly into Detroit's starting rotation in the final third of the season. For the Sea Wolves, he posted a 10-3 mark and an ERA of 2.42. Ledezma had been claimed from the Red Sox in the Rule 5 draft and spent all of the 2003 season with the Tigers. He was sent to Erie in 2004 to gain more experience, and he thrilled local fans with his dominant pitching. After his promotion to the Tigers, he was 4-3 in eight starts. (Courtesy Rich Abel.)

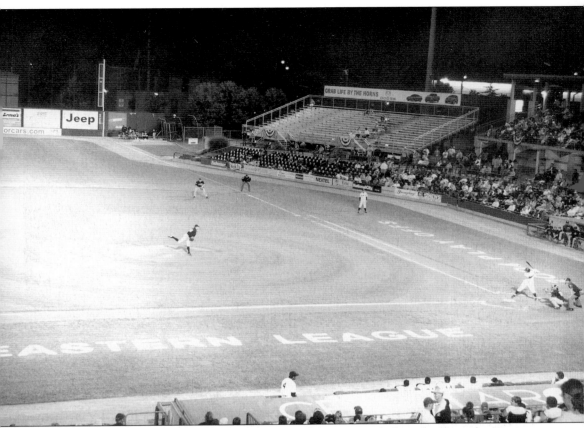

The 2004 Sea Wolves posted an 80-62 record, good for a second-place finish in the Eastern League's Southern Division. In the first round of the playoffs, Erie took on the Altoona Curve but was swept in three straight games. This action occurred during Game 3, won by Altoona 14-4.

These tickets to opening night at Jerry Uht Park on June 20, 1995, were printed before the park was named. Note that "Erie Ballpark" appears on the tickets.

ERIE MINOR-LEAGUE TEAM RECORDS 1995–2004

YEAR	NAME	LEAGUE	AFFILIATE	RECORD	MANAGER
1995	Sea Wolves	NYP	Pittsburgh	34-41	S. Little
1996	Sea Wolves	NYP	Pittsburgh	30-46	J. Richardson
1997	Sea Wolves	NYP	Pittsburgh	50-26	M. Brown
1998	Sea Wolves	NYP	Pittsburgh	26-50	T. Woodson
1999	Sea Wolves	Eastern	Anaheim	81-61	G. Templeton
2000	Sea Wolves	Eastern	Anaheim	47-94	D. Wakamatsu
2001	Sea Wolves	Eastern	Detroit	84-58	L. Pujols
2002	Sea Wolves	Eastern	Detroit	52-89	K. Bradshaw
2003	Sea Wolves	Eastern	Detroit	72-70	K. Bradshaw
2004	Sea Wolves	Eastern	Detroit	80-62	R. Sweet